BRIGHTON
PHOTO
BIENNIAL
200

sity College the Crea
ry, s ar

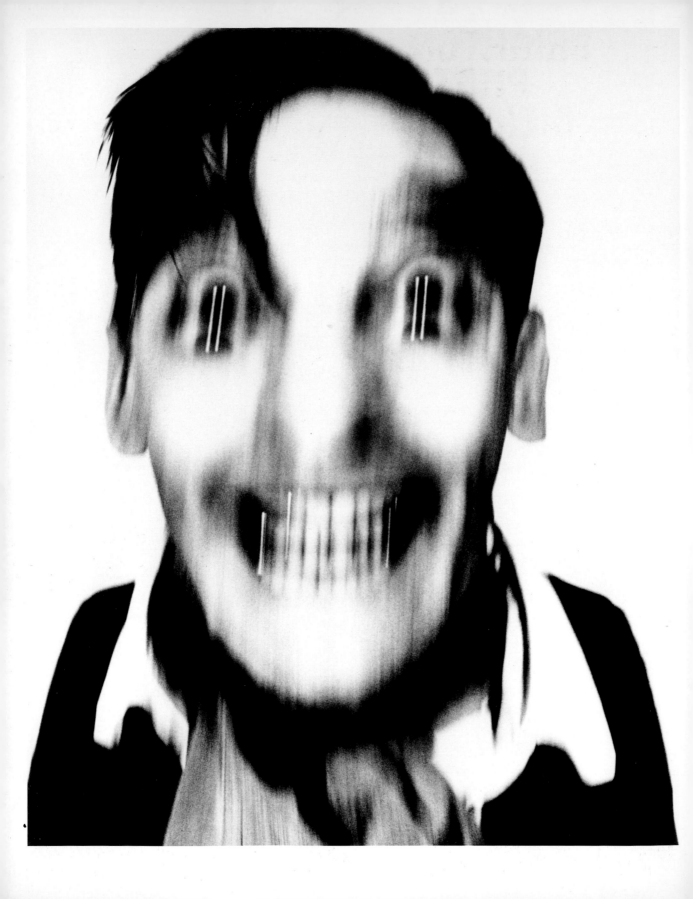

BRIGHTON PHOTO BIENNIAL 2006

Adel Abdessemed
Richard Avedon
Phyllis Baldino
David Claerbout
William Eggleston
Walker Evans
Paul Fusco
Alfredo Jaar
Gabriel Kuri
Van Leo
Glenn Ligon
Steve McQueen
Lee Miller
Richard Misrach
Henna Nadeem
Mitra Tabrizian
Fiona Tan
Kara Walker
Andy Warhol
Orson Welles

Curated by Gilane Tawadros

bpb photoworks

[p.2]
Richard Avedon
Killer Joe Piro, dance teacher,
New York, January 3, 1962

Walker Evans
(Brighton from the Palace Pier)
1973

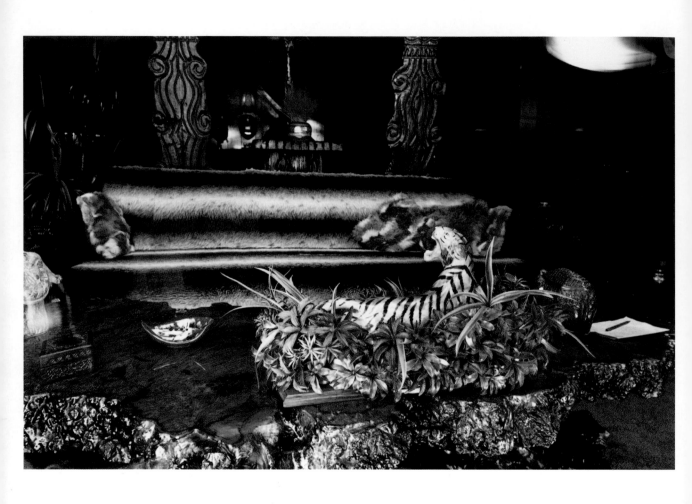

William Eggleston
Untitled, Memphis, Tennessee, 1984
From the Portfolio: *William Eggleston's Graceland*

BRIGHTON PHOTO BIENNIAL 2006
John Gill, Executive Director

Brighton Photo Biennial is delighted to present its second edition curated by Gilane Tawadros, an independent curator and writer who in recent years has built an international reputation as Director of the Institute of International Visual Arts (inIVA). She has been working with galleries and visual arts organisations in and around Brighton and Hove to develop an exciting series of exhibitions, publications and events. Bringing together historical, contemporary and newly commissioned photographic and moving image works, Gilane's Biennial features twenty artists who explore the thin line between past and present, fact and fiction, illusion and reality. The Biennial and its partners are grateful to her for her enthusiasm and commitment to the project, and for the collegiate spirit with which she has developed the exhibitions programme.

Our principal partners are the University of Brighton, Photoworks, Arts Council England, Brighton & Hove City Council and our partner venues and arts and education organisations in the region. The University of Brighton hosts the Biennial office, and funds the Biennial both directly and indirectly, and has been an important and continuing source of support. Photoworks, the photographic commissioning and publishing agency based in Brighton, kept the Biennial flame burning and helped secure its future, and is now both a key publishing and production partner. The Biennial could not thrive without their practical support, advice and help and we thank both organisations for it.

Our partner venues have made every effort to accommodate the wishes and aspirations of the Biennial's curator, the invited artists and lenders of work. Brighton Museum & Art Gallery have organised the keynote exhibition, *Nothing Personal*, a reassessment of a significant series of images by Richard Avedon in the context of the work of five other crucially important artists from the United States. Additionally, the Museum in collaboration with Screen Archive South East and the Biennial have commissioned Fiona Tan to make new work at Brighton Royal Pavilion for public presentation in the Royal Pavilion Gardens. Photoworks are presenting newly commissioned work by Henna Nadeem at Charleston Farmhouse, and previously unseen images by Walker Evans at the Gardner Arts Centre. Fabrica is hosting a new installation by Alfredo Jaar, originally commissioned this year by Houston Fotofest, and The University of Brighton Gallery is showing a new work by David Claerbout, as well as recent work by Adel Abdessemed and a major collection of self-portraits from the Van Leo Archive in Cairo. Gilane Tawadros has collaborated with David A Bailey, Associate Curator at the De La Warr Pavilion, on *Voodoo Macbeth*, an exhibition of archive and contemporary works by a wide range of international artists.

This year we are delighted to be working in partnership with Brighton & Hove City Council and the University of Brighton on a new initiative, *Photography is Everywhere*, the largest education project so far undertaken by the Biennial. Second year photography students are working with a trainer in five Hove schools to deliver workshops as part

8

of an accredited BA extension course developing
their professional practice and their range of
skills. Our year-round education programme has
recently included artist-led projects at Sussex
Medical School, the Mass Observation Archive
at the University of Sussex and at Ore Valley in
Hastings, full details of which are included here.

The Biennial and the Brighton Photo Fringe
have worked together from the beginning, as
independent organisations in close partnership.
Sustainability is, of course, a principal concern
for both of us, and both organisations are based
on a foundation of partnership and collaboration.
Agreement of our complementary missions came
early and our partnership has continued to thrive,
based as it is on mutual understanding and trust.
The Biennial provides information, advice and
support to the Fringe, identifying opportunities
for collaboration, for example in the organisation
of portfolio reviews, education, outreach and
interpretive events. The Biennial applauds the work
of the many volunteers who have helped develop
its own work and that of Brighton Photo Fringe.

This year the Biennial has established itself as
an ongoing, vibrant and vital organisation at the
centre of partnerships that are making Brighton
the most exciting centre of photography in the UK.

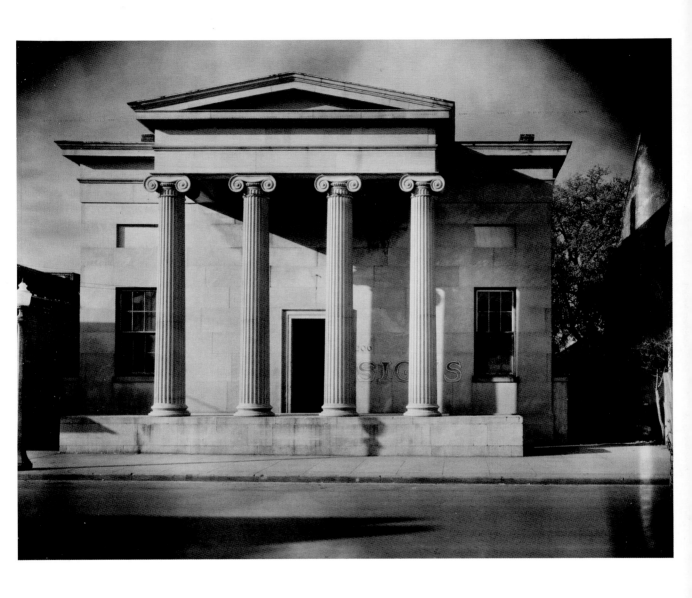

Walker Evans
Greek Temple Building, Natchez,
Mississippi, 1936

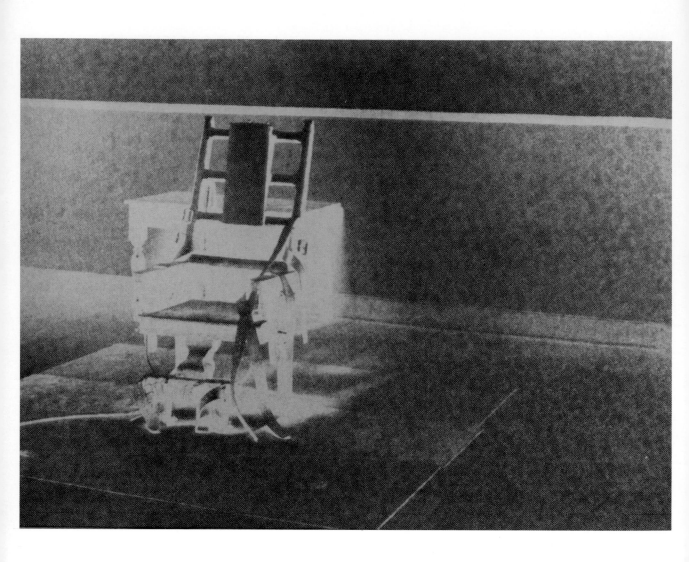

Andy Warhol
[no title]
Screenprint on paper, 1971

EMPIRE OF INNOCENCE
Gary Younge

The idea of empire is central to Brighton Photo Biennial 2006. In particular the photographic works assembled in various exhibitions and venues in and around the city deal with what this year's curator Gilane Tawadros has called 'the compelling attractions as well as the dark shadows inherent in all empires'. At the heart of this theme is the place of America, whose sense of national identity and role as a post-war imperial power was so effectively undermined by Richard Avedon and James Baldwin's *Nothing Personal* (1964), a book which has been one of the Biennial's main inspirations.

Gary Younge is a British writer based in the US and in this short essay, which acts as a preface to the other commentaries in the book, he stresses the continuing, contemporary relevance of the empire theme by giving his view of America's growing influence now in world affairs, pointing to the illusions and contradictions in the country's view of itself and its international responsibilities.

In a global poll conducted by the Washington-based Pew research centre this Spring came a partial explanation for the gulf between how most Americans regard their country – a benign exporter of democracy and freedom – and how much of the rest of the world experiences it. The survey showed that only seventy five percent of Americans had heard reports of abuses in both Abu Ghraib prison in Iraq and at Guantanamo Bay, Cuba, compared to ninety percent of Western Europeans and Japanese. In other words Americans were less likely to be aware of atrocities and human rights abuses inflicted by other Americans allegedly committed in the interests of their own security, than people in other countries.

'The way we see things is affected by what we know and what we believe,' wrote John Berger in *Ways of Seeing*. 'The relation between what we see and what we know is never settled.' The way we do not see things is similarly affected by what we want to know and believe. For the problem here was not that one in four Americans had not heard of these abuses – the American press is not that bad and Americans are not that stupid – but that they chose not to hear. Not knowing is the privilege of the powerful.

Britons choose to forget the Empire; their former colonies do not have that luxury. The global calendar is sprinkled with national holidays when different countries celebrate their independence from us; but in Britain those days go by unnoticed. For Britons to learn the stories of oppression

12

and brutality that presaged each of those independence days would demand a profound and painful engagement with their history.

Similarly for that swathe of Americans to 'hear about' Abu Ghraib and Guantanamo would require a reckoning with what their country does and what they believe it to stand for. 'We are the sum of the things we pretend to be,' wrote Kurt Vonnegut. 'So we should be careful what we pretend to be.' Americans pretend to be innocent. But while they treasure this innocence they are also exceptionally careless with it. For they keep on losing it. They lost it during Pearl Harbour, Hiroshima, the civil rights era, Vietnam, the assassinations of president John. F Kennedy, his brother Bobby and Martin Luther King, Watergate, Lebanon, Iran-Contra, 9/11 and now Iraq. And each time they misplace it, they manage to find it again just in time for the next attack that they either deliver or receive.

This innocence has two qualities. The first is that it is devoid of history. To be innocent, almost by definition, you cannot have a past. For a past will give you experience and with experience comes the opportunity to learn. The second is that it is devoid of responsibility. To be innocent, by definition, is to be free of guilt. You cannot be called upon to fully answer for the consequences of your actions if you had no way of knowing what they would be. So it is not difficult to see why they would claim this innocence. It leaves them free of any liability for what they have done or what they are about to do. Nor is it difficult to see why it should be challenged. For not only does it infantilise Americans, but it provides cover for a well-crafted sense of wilful ignorance.

The latent yet strongly-held belief that the US is a force for good in the world and that its military

Phyllis Baldino
Mars/Rome/NY De La Warr, 2006
Two channel video installation
Left channel: 14min 22sec
Right channel: 9min 24sec
Video Still

13

exists to impose that good when other means have failed is both so pervasive and dominant in the American psyche that it needs no evidence to sustain it. Support for the troops, regardless of their mission, is an inviolable fact of public discourse. Liberals sport bumper stickers stating: 'Support the troops, oppose the war'. Flight attendants regularly announce the presence of a returning marine on board to rousing applause. 'I thought I was going to free Iraqi people,' said Darrell Anderson, 24, when asked why he had joined the military. 'I thought I was going to do a good thing. I didn't know anything about the politics of it.'

But political reality interrupts such innocence in the cruellest ways. I met Darrell at a picnic for war resisters in Fort Erie, Canada, where he is now claiming asylum having deserted from the military. He refused to return after he found himself in Baghdad 'cocking my weapon at innocent civilians without any sympathy or humanity.' Not everyone engages with these contradictions with Anderson's degree of mature reflection. For some ignorance represents not just a passive lack of knowledge but a deliberate *modus operandi*. 'The best way to get the news is from objective sources,' said President George Bush. 'And the most objective sources I have are people on my staff.'

This is not innocence, it is dangerous self-indulgence that is currently played out in the war on terror. By attacking regimes and movements the US once supported, such as Iraq and the Taliban, and giving unequivocal backing to governments with poor human rights records, such as Saudi Arabia and Israel, it behaves as though the past has no legacy and the present has no consequences. And so 'now' becomes its own abstract point in time – neither shaped by what has gone before nor able to shape what comes after. Instead we live in an ever-evolving present with an ever-changing enemy. As America's targets grow so does America become itself a bigger target. The innocence comes and goes; the threat to world peace, however, feels permanent.

Gary Younge is the New York correspondent for The Guardian.

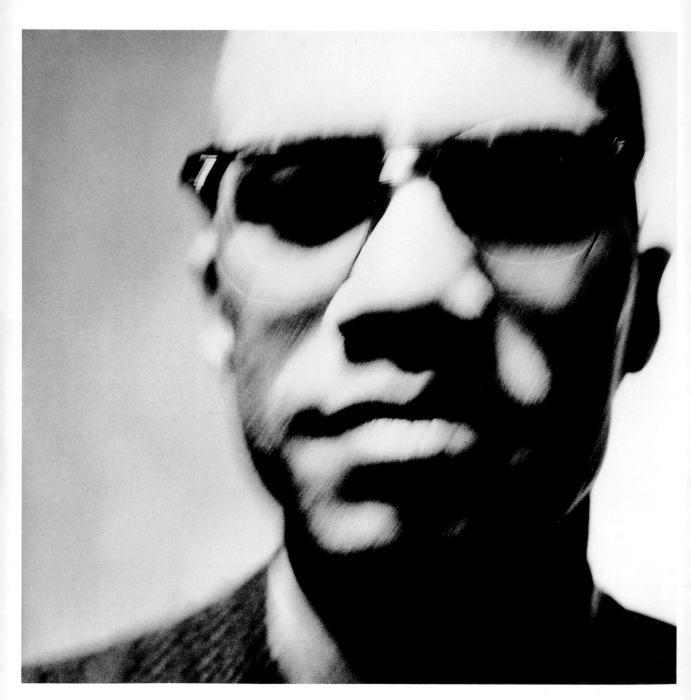

Richard Avedon
Malcolm X, black nationalist leader,
New York City, March 27, 1963

STRANGERS AND BARBARIANS: REPRESENTING OURSELVES AND OTHERS
Gilane Tawadros

'The lie has penetrated to our most private moments, and the secret chambers of our hearts. Nothing more sinister can happen, in any society, to any people. And when it happens, it means that the people are caught in a kind of vacuum between their past and their present – the romanticized, that is, the maligned past, and the denied and dishonoured present. It is a crisis of identity. And in such a crisis, at such a pressure, it becomes absolutely indispensable to discover, or invent – the two words, here, are synonyms – the stranger, the barbarian, who is responsible for our confusion and our pain. Once he is driven out – destroyed – then we can be at peace: those questions will be gone. Of course, those questions never go, but it has always seemed much easier to murder than to change. And it is really the choice with which we are confronted now.'

James Baldwin, *Nothing Personal* [1]

A man, beginning to grow slightly bald and wearing only swimming trunks, a wristwatch and a pair of thick-rimmed glasses, is bent over on his hands and knees in deep concentration. His hands are moulding the base of a sand castle. It will be the sixth in a small accumulation of sand castles, a mini-metropolis in sand. Each one looks like a cross between Antonio Gaudi's organic architectural structures and what were once New York's 'Twin Towers'. Far off in the distance, barely perceptible at first, is the vague outline of a woman on an inflatable lilo. The man is lost in thought, completely absorbed in his task. He seems entirely unaware of any other human being, or indeed of the camera. Shot on Santa Monica beach, this photograph is the opening image of the book *Nothing Personal*, a unique collaboration between the photographer **Richard Avedon** and the writer **James Baldwin**.

First published in 1964, one year after the assassination of John F. Kennedy, *Nothing Personal* was a compelling and disturbing portrait of the United States of America. Combining images and text in an elegant and provocative way, the artistic collaboration between Avedon and Baldwin was an incisive analysis of the USA in the mid-

1 James Baldwin in Richard Avedon and James Baldwin, *Nothing Personal* (New York: Atheneum, 1964)

Richard Avedon
Santa Monica Beach,
September 30, 1963

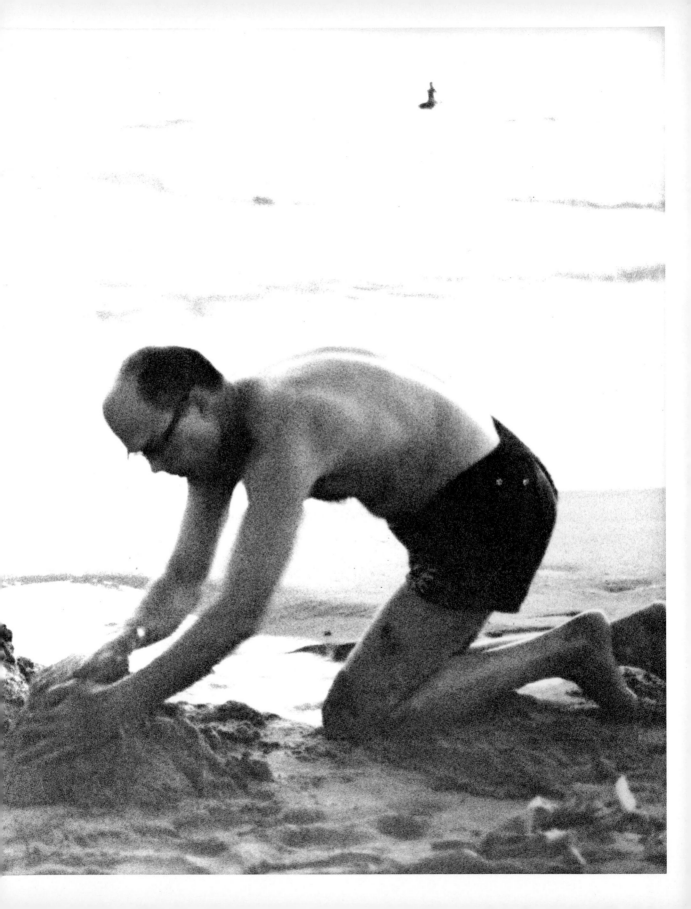

1960s and its inherent contradictions: the tension between what Baldwin called its invented self and its undiscoverable self; between its romanticized past and its denied present, between its image and its reality. Avedon and Baldwin's project is still relevant forty years later, perhaps more so, provoking as it does questions about the state of the American nation and about the United States of America's increasingly imperial role on the world stage. It sets a challenge to its viewers and readers to disentangle fact from fiction and to confront present realities, informed by an unromantic understanding of the past. Above all, Avedon and Baldwin's collaborative venture sought to highlight the gap between how the nation saw itself and how it actually was, stripping away illusions of a comfortable and reassuring surface reality and replacing them with a portrait of a dysfunctional nation, locked into a history of violence and injustice.

Avedon and Baldwin's landmark photographic book was the inspiration for the Brighton Photo Biennial 2006 and the starting point for an exploration of the limits of representation, both photographic and political. Bringing together historical, contemporary and newly-commissioned photographic and moving image works, the second Brighton Photo Biennial features works by artists who explore, in different ways, the thin line between past and present, fact and fiction, illusion and reality. The event centres on Brighton Museum and Art Gallery and the historic gardens of the Royal Pavilion, the former being the venue for a major exhibition which takes it title from Avedon and Baldwin's book and assembles historical and contemporary photographic work by six major American artists. One of the most eccentric and distinctive buildings in England, the Royal Pavilion Brighton, was developed by the architect John Nash into an exuberant Indian and Chinese-inspired

summer palace for the Prince Regent in the early part of the nineteenth century; a flamboyant architectural expression of an empire that was rapidly expanding across the globe. Drawing connections between Britain then, as an emerging imperial nation and the United States in recent decades, the exhibition *Nothing Personal* investigates the compelling attractions as well as the dark shadows inherent in all empires, past and present. Throughout Brighton and along the South East Coast are a range of other solo and group exhibitions of established and emerging international artists, presented across a number of distinctive sites including the University of Brighton Gallery, Fabrica, Charleston Farmhouse, the De La Warr Pavilion and the Gardner Arts Centre.

At a moment when the boundaries of democracy are being tested and pushed to new limits, provoking questions about civil liberties, human rights and electoral legitimacy in different parts of the world, it seems timely to consider how the photographic image itself (and in the widest possible sense) has been the focus for forays, experiments and elaborations on the limits of representation. As Susan Sontag wrote two years ago of the photographs of Iraqi prisoners taken by US soldiers in Abu Ghraib prison: '...the horror of what is shown in the photographs cannot be separated from the horror that the photographs were taken...where once photographing war was the province of photojournalists, now the soldiers themselves are all photographers – recording their war, their fun, their observations of what they find picturesque, their atrocities.'[2] We are participants in a political moment when democracy is invoked as a standard bearer for acts which are far from democratic and when the tools of representation are being deployed to represent acts that should not be enacted, let alone represented.

2 Susan Sontag, 'The Photographs are Us', *The New York Times Magazine*, May 23, 2004, pp.26-27

19

'The photographs are us,' wrote Sontag of the horrific pictures from Abu Ghraib[3]. The pictures, she argued, could not be seen as isolated incidents or the representations of maverick individuals but rather were the direct outcome of the political actions of the American nation. Only by recognising how the individual and the national intersect with one another can one understand how these photographs stand as material evidence of the brutal and ubiquitous impact of the political on the personal. It is precisely this relationship between different regimes of representation – political and pictorial, collective and individual, written and visual – that makes Avedon and Baldwin's *Nothing Personal* such a seminal and groundbreaking artistic project.

Written and photographed as parallel but distinct elements, which were subsequently woven together by Avedon and the designer Marvin Israel (with editorial assistance from Marguerite Lamkin and James Baldwin's brother David), *Nothing Personal* was the second collaboration between Avedon and Baldwin. They attended the same high school, DeWitt Clinton High, in the Bronx where they worked together on the school magazine *Magpie* along with Emile Capouya who later became literary editor of the *Nation*.

There is no preface or introductory text to *Nothing Personal*. Instead, the book opens with a double spread of the lone builder of sand castles, followed by a sequence of wedding photographs shot by Avedon in the Marriage Bureau at New York City Hall. It is the sheer ordinariness of this subject matter as commonplace occurrences from everyday life (holidays and weddings must surely be the most commonly photographed events in the family album) which sets the mundane scene for Avedon and Baldwin's spectacular incision into the heart

of America and the explosion of its myth of itself. 'It is, of course, in the very nature of the myth,' writes Baldwin, 'that those who are its victims, and, at the same time, its perpetrators, should, by virtue of these two facts, be rendered unable to examine the myth, or even to suspect, much less recognise, that it is a myth which controls their lives.'[4] In *Nothing Personal*, photographer and writer set out to immerse themselves in everyday American life and its representations, extracting from the individual and the commonplace a picture of the USA's collective social and political reality in the mid-1960s. There is nothing personal about Avedon and Baldwin's assault and everything political about their elegant dissection of America.

While Avedon sets the scene with images of ordinary Americans doing everyday things like getting married and playing on the beach, Baldwin opens his text with a television remote control in his hand and acerbic reflections on the vain self-absorption that dominates American television commercials. His words are delivered in the form of a rapid-fire commentary on the tide of fleeting television images, which he observes before moving rapidly into a sharp de-bunking of the nation's founding mythology: 'To be locked in the past means, in effect, that one has no past, since one can never assess it, or use it: and if one cannot use the past, one cannot function in the present, and so one can never be free. I take this to be, as I say, the American situation in relief, the root of our un-admitted sorrow and the very key to our crisis'.[5] Baldwin's ferocious attack on the US media – television, Hollywood and magazines – is an attack on the superficiality of America's representations of itself which lulls its citizens into a false sense of security and, even, a misplaced euphoria. 'I know', writes Baldwin, 'that these are strong words for a sunlit, optimistic land, lulled for so long into such

3 Ibid.

4 Baldwin, op. cit.
5 Ibid.

20

an euphoria, by prosperity (based on the threat of war) and by such magazines as READER'S DIGEST, and stirring political slogans, and Hollywood and television. (Communications whose role is not to communicate, but simply to reassure).'[6] Throughout the book, Baldwin and Avedon repeatedly challenge America's representations of itself and the tenuous, even dangerous, link between these representations – written, visual and political – and reality.

Importantly, Avedon's photographs do not illustrate Baldwin's text. Nor does Baldwin's text describe or comment upon Avedon's pictures. Images and text work together in *Nothing Personal* like two distinct melodies in a musical score, coming together at certain points and diverging at others but underpinned by a consistent, shared base line which repeatedly pokes and prods at the nation at a critical point in its history. The assassination of John F. Kennedy in 1963 had shocked America and the immense grief that accompanied his death was clearly tied to what JFK represented. Even if the perception of a new era in North American politics did not match the reality, nonetheless JFK symbolised to many the hope and possibility of progressive social change. One year later, *Nothing Personal* reads like a forensic report on the state of the nation in the aftermath of Kennedy's death. Through a syncopated relationship of image and text, the book compiled evidence for the prosecution uniting the passionate and fluent language of Baldwin with the cool but damning material corroboration of Avedon's camera.

JFK's assassination was still fresh in the minds of the American people when five years later Robert F. Kennedy (JFK's brother and New York's Senator) was assassinated on 5 June 1968 whilst he was running for the presidency. On 8 June, his funeral took place at St Patrick's Cathedral, New York City and his body was carried on a funeral train from New York to Washington D.C. as Abraham Lincoln's had been over a century earlier. The photojournalist **Paul Fusco** travelled with Robert F. Kennedy's funeral train and recorded the many thousands of people that lined the railway tracks. As with his brother before him, and even more so, Robert Kennedy represented the possibility of political, social and economic change. Fusco's camera records the masses of people, black and white, young and old, who waited patiently to salute the passage of Robert Kennedy's body from his political constituency to the political capital of America.

As the writer Norman Mailer recalled of the honour guard around Kennedy's coffin in St Patrick's: 'Lines filed by. People had waited in line for hours, five hours, six hours, more, inching forward through the day...The poorest part of New York had turned out, poor Negro women, Puerto Ricans, Irish washer-women, old Jewish ladies who looked like they ran grubby little news-stands, children, adolescents, families, men with hands thick and lined and horny as oyster shells, calluses like barnacles, came filing by to bob a look at that coffin covered by a flag.'[7]

Thousands more waited patiently in the searing June heat to catch a glimpse of Kennedy's coffin as it travelled along America's East coast, supported by two chairs and visible through observation windows in the last carriage of the train. Fusco's camera, trained on the waiting crowds, moves from the densely crowded platforms in New York and New Jersey in the bright midday sunlight through to the trickle of small groups standing beside the tracks in the ebbing light near Washington D.C. Some wave, some salute, others cry. Some are dressed informally in summer clothes, women with their hair still in curlers; others wear suits,

6 Ibid.

7 Norman Mailer, 'The Promise', in Paul Fusco, *RFK Funeral Train* (New York: Magnum Photos in association with Umbrage Editions, 2000.)

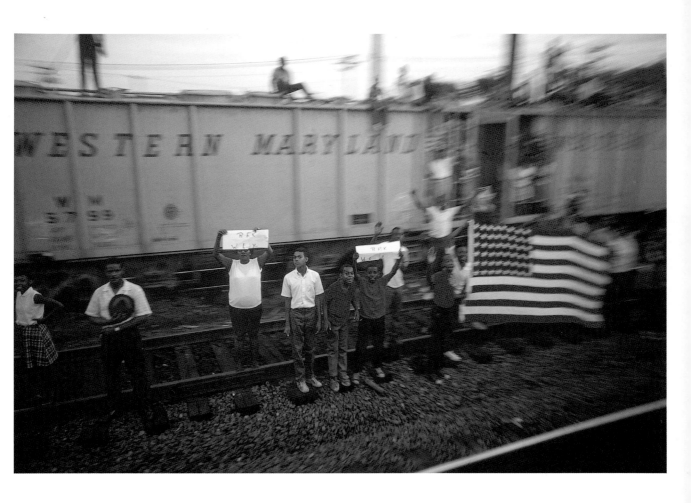

Paul Fusco
RFK Funeral Train
1968

22

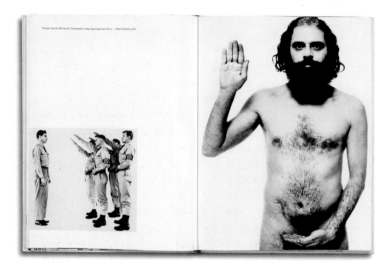

formal clothes or uniforms. Many hold flags with the stars and stripes, handkerchiefs or homemade banners, proclaiming: 'So-long Bobby'. Mirroring Fusco's own recording of the journey, many make their own record of the funeral train on hand-held photographic and movie cameras. There is a sense in these photographs that there is more passing here than a man's coffin. It is as if with the deaths of John and Robert Kennedy, a particular vision for America's future that would break once and for all with the injustices and inequalities of the past, had also died. Robert Kennedy embodied an idealistic aspiration for a re-casting of the American dream in a new image of itself. In his eulogy at Robert Kennedy's funeral, Edward Kennedy quoted one of his brother's often-repeated invocations: 'Some men see things as they are and say why. I dream things that never were and say why not.'

In *Nothing Personal*, the main body of photographs, arranged and edited meticulously to different scales and in studied juxtapositions, portray an eclectic mix of US citizens, both known and unknown. George Lincoln Rockwell, Commander of the American Nazi Party, standing in front of his saluting, uniformed recruits sits alongside a large-scale naked portrait of Allen Ginsberg, one hand cupped beneath his navel and the other held up as though the Beat poet were about to swear allegiance to an unseen American flag. An imposing portrait of William Casby, 'born in slavery', occupies its entire page. On the facing page is a small, square portrait of Adlai Stevenson, 'representative of the United States in the United Nations'. It becomes obvious as you turn the pages of the book that Avedon's visual juxtapositions are based as much on political and social considerations as they are on aesthetic and pictorial ones: How is or should America be represented?

Spread from Richard Avedon and
James Baldwin, *Nothing Personal*, 1964.
George Lincoln Rockwell,
Commander of the American
Nazi Party / Allen Ginsberg, Poet

23

Other portraits include those of Dorothy Parker (writer), Marilyn Monroe (actress), Bertrand Russell (philosopher), Jerome Smith and Isaac Reynolds (civil rights workers and students) and Killer Joe (dance teacher). Levels of discomfort and ill-ease increase as you move through the consecutive pages until you reach the portrait of Major Claude Eatherly. His head and shoulders bleed to the edges of the photograph. He squints, his hand held as if to shield his eyes and he looks off into the distance, beyond Avedon the photographer, beyond us the viewers. There is a disturbing vacancy to his gaze. A pilot at Hiroshima in August 1945, Major Eatherly appears disorientated and confused. Apparently he suffered mental health problems and had been admitted to an asylum rather than prison after committing a petty crime. When Avedon met him at a motel close by the asylum after he had been discharged, Eatherly was entirely monosyllabic. He had marks on the side of his head and Avedon suspected that he had been given electric shock treatment.[8]

Avedon's portrait of Claude Eatherly is quite literally a prologue to madness. It precedes the most disturbing images of all in the book: portraits of patients in a mental institution. Photographed over a number of days in East Louisiana Mental Hospital, Jackson, Louisiana, these images evoke the dark interior of the American nation. They are difficult photographs to look at, representing as they do the fact of madness and the physical space which contains and shelters from public view those for whom the line between illusion and reality has been completely obliterated. This harrowing sequence of images is followed by more photographs shot on Santa Monica Beach – a heavily pregnant woman whose partner touches her swollen belly; a mother and son holding each other tightly on the seashore; a man supporting the weight of his infant son

in the palm of his hand. The line between sanity and madness, hope and oblivion sketched in this way by Avedon's combinations of images and by Baldwin's words is a fine and precarious one: 'The sea rises, the light fails, lovers cling to each other and children cling to us. The moment we cease to hold each other, the moment we break faith with one another the sea engulfs us and the light goes out'.[9]

It is no coincidence that the pictures in the East Louisiana Mental Hospital were taken in the South. Some of the most striking of Avedon's portraits in the book were shot there. Assisted by Marguerite Lamkin, a descendent of Robert E. Lee, and her vast network of family and friends in Louisiana, Avedon was able to secure introductions to and photograph, among others, the Generals of the Daughters of the American Revolution (a lineage membership organisation established in the nineteenth century for women who can prove their descent from an ancestor who helped to achieve US independence) and Leander Perez (an unapologetic racist and anti-Semite with his own private army from whom Avedon concealed his Jewish identity) as well as gaining access to the East Louisiana Mental Hospital. It is in the Deep South where, according to Baldwin, the United States appears so visibly locked into its past, a prisoner of its history and therefore unable to assess or use it.

It was, perhaps, in an attempt to unlock that past that **Walker Evans** took a series of photographs in the mid-1930s of neglected and abandoned plantation houses. Reminiscent of Atget's haunting nineteenth-century photographs of de-populated Paris streets, Evans's photographs of southern plantation architecture had been commissioned by a wealthy New York industrialist, Gifford Cochran, and were intended to illustrate a book that was never

8 Unpublished conversation with Marguerite Lamkin, 2006.

9 Baldwin, op. cit.

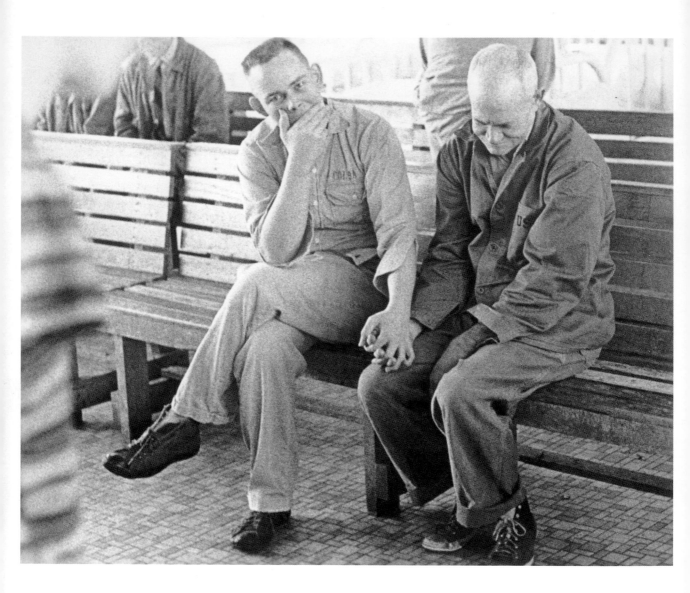

Richard Avedon
Mental Institution, East Louisiana
State Mental Hospital, Jackson,
Louisiana, February 15, 1963

published. Shot in a number of locations across the South including Louisiana, Georgia and Mississippi, Evans's haunting black and white photographs focus on the derelict yet still imposing properties of Southern landowners. There is no trace in Evans's photographs of any human presence and the buildings themselves are entirely devoid of any trace of their former inhabitants. The progressive decay in the fabric of the buildings and the dishevelled remains of trees felled by the wind are at odds with the controlled symmetry and order of the neo-classical plantation buildings. It is as if the combined effect of human neglect and natural decay had finally begun to erode the dominance of these silent, brooding protagonists in slavery and Civil War.

Around about the same time, now commissioned by a government agency, the Farm Security Administration (FSA), Evans began another series of photographs, this time of Civil War Monuments. These melancholic statues of Civil War commanders and their foot soldiers are portraits of a very distinctive kind. Shooting close up, either face on or directly from below, Evans records these forlorn figures without any peripheral details, isolated from their surroundings. Frozen in their gallant poses and full military dress, these heroes of the American South appear as mute witnesses locked forever in the past. Significantly, all of Evans's photographs of Civil War Monuments are taken in Vicksburg, Mississippi, which was besieged by Yankee troops and fell on the 4 July 1863. With the fall of Vicksburg, the fall of the South had been assured.

[2]

The Violence of Strangers
Avedon's images and Baldwin's text are shot through with intimations of violence and its effects from its perpetrators – knowing or unknowing accomplices like Leander Perez, or Major Claude Eatherly – through to its victims like Cheryl Crane, daughter of Lana Turner (who murdered Johnny Stompanato, the gangster who had violently threatened and abused her mother) and Martin Luther King III, son of Reverend Martin Luther King, the civil rights leader who would be murdered in Memphis, Tennessee two months before Robert Kennedy. Explaining his decision to publish the portraits of Cheryl Crane and Martin Luther King III on facing pages, Avedon told his assistant Marguerite Lamkin that they had similar eyes and similarly shaped faces. Aesthetic symmetry was certainly a consideration for Avedon in juxtaposing the two images, but so too was the asymmetry of their experiences: the one, driven to murder to defend her mother from violence; the other, the child of a man who had adopted non-violence as a strategy to challenge the racism and violence of segregation in the South.

Violence, and in particular, the recent murder of John. F. Kennedy, cast a dark shadow over *Nothing Personal,* which in turn strangely seems to foreshadow the assassinations of other political leaders that followed. Referring to John F. Kennedy's assassination, Baldwin reflected on the fact that the murder had been attributed to strangers and barbarians: 'Quite apart, now, from what time will reveal the truth of this case to have been, it is reassuring to feel that the evil came from without and is in no way connected with the moral climate of America: reassuring to feel that the enemy sent the assassin from far away, and that we, ourselves, could

never have nourished so monstrous a personality or be in any way whatever responsible for such a cowardly and bloody act. Well. The America of my experience has worshipped and nourished violence for as long as I have been on earth. The violence was being perpetrated mainly against black men, though – the strangers; and so it didn't count. But, if a society permits one portion of its citizenry to be menaced or destroyed, then, very soon, no one in that society is safe. The forces thus released in the people can never be held in check, but run their devouring course, destroying the very foundations which it was imagined they would save'.[10]

The legacy of murder and violence in the past, which continues to haunt the American present, is invoked in the epic landscapes of **Richard Misrach**'s *Desert Cantos*, a series of photographs which chronicles the deserts of the American West. In the cultural imagination, the American desert remains an icon of the country's myth of itself and its self-representation as an epic, frontier nation, conquering its human and natural enemies to establish the foundations of the heroic nation. The desert represents a kind of theatre of fears and dreams for the burgeoning new nation, but it also represents the killing fields of a country forged in violence and conflict. Misrach's monumental colour photographs are compellingly beautiful but unromantic images of a landscape ravaged by natural and human interventions. His images bear the traces of those interventions: devastating desert fires, discarded military equipment, bomb craters and cattle pits. Unlike the cattle of Hollywood Westerns herded across miles of arid terrain by tenacious cowboys, the lifeless animals of Misrach's work are piled high in vast pits, sick, mutilated or diseased, with several carcasses one on top of the other, surrounded by rancid liquid, discarded petrol

cans, empty cardboard boxes and other human debris. Occasionally Misrach's camera falls on a lone animal, and in one of these photographs the animal's head is entombed and encrusted in sand creating a disturbing and elegaic *memento mori*. It is partly the fragility of human existence to which Misrach alludes and partly to the precariousness and inevitable demise of the American dream.

Andy Warhol's *Electric Chairs* can also be seen as a contemporary re-working of the *memento mori* and a reflection on the darker side of the American dream. Contrasting with his glamorous celebrity portraits, Warhol's *Electric Chairs* are portraits of a very different kind. Mutating through different colour combinations, the vacant electric chair in an empty execution chamber is violently vivid in some prints and barely visible in others. They are dark and haunting images, whose morbid subject moves in and out of focus. Warhol began using the image of the electric chair in 1963, the same year as the last executions were held in New York State. In the 1960s, the legality of the death penalty in America was being seriously challenged as a 'cruel and unusual' punishment and therefore unconstitutional under the Eighth Amendment. As a consequence, there was a voluntary moratorium in most states between 1967 and 1972 when Warhol made these silkscreen prints. There had, however, been other events in Warhol's life that brought violence closer to home. On 3 June 1968 Warhol was shot in the stomach by an actress called Valerie Solanas, an occasional visitor to 'The Factory'. Warhol was rushed to the operating room. Following his surgery, he learnt of the assassination of Robert Kennedy.

Seen together, Misrach and Warhol's images create a new visual vocabulary for representing the American nation, one less dependent

10 Ibid.

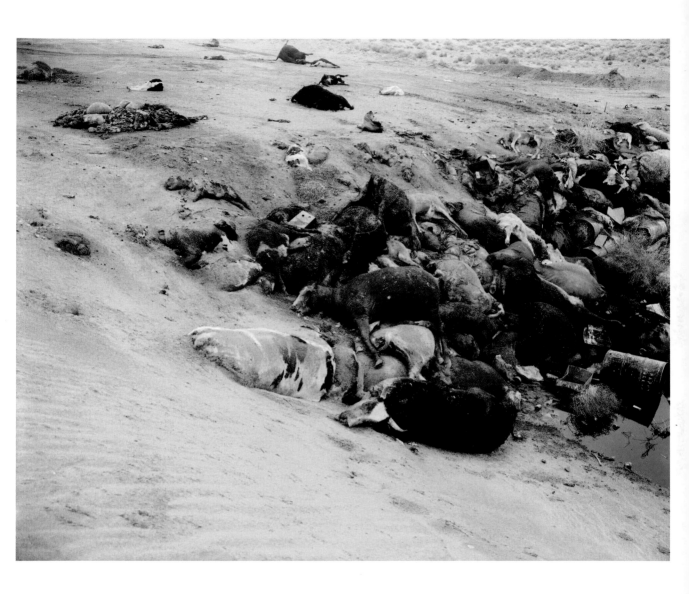

Richard Misrach
Dead Animals #1, Nevada,
from the series *The Pit,* 1987

28

on illusion and fantasy. Rather, they paint an exquisite yet bleak picture of the reality of America reminiscent of writers like James Ellroy and Cormac McCarthy, whose unrelentingly violent portrayal of America has sought to redress the balance of unbridled optimism with a deep pessimism.

Whereas Misrach's *Desert Cantos* have been photographed over a period of two decades in different locations and at various times of day, **David Claerbout**'s *White House* (2006) was filmed over a single day against the backdrop of a neo-classical house in southern France that is reminiscent of Walker Evans's photographs of plantation houses in the American South. Over an interval of thirteen hours, the same events are re-played over and over again. Two men, speaking to each other in French, are in discussion. As they talk and move around in the shadow of the columned porch of the house, the camera moves also, observing them from different angles. There is nothing explicit or tangible to explain what happens next.

Dissolving the boundaries between photography and film, Claerbout's work frequently puts into question the reassuring stillness of the photographic image and the inevitable narrative progress of the cinematic image. His film and photography installations, tinged with melancholy, disorient the viewer by endowing still images with movement and by slowing or even halting the cinematic passage of time. In works such as *Vietnam, 1967, near Duc Pho (reconstruction after Hiromichi Mine 'Friendly Fire')* where the artist re-animates a historical photograph of a US fighter plane disintegrating in mid-air, his stated desire to 'unfreeze the photograph' can also be understood as a desire to unfreeze the past in a way which disturbs the present. Unlike his earlier works, *White House* breaks through the surface

David Claerbout
White House, 2006
single channel widescreen video projection,
colour, stereo, 13 hours 27 min

29

of the single, still photograph, transforming the inert and fleeting representation of violence into a dynamic but seemingly endless repetition of events.

The man hesitates briefly as he straddles the other and raises a heavy rock above the injured man. When the weight of the stone crushes his skull, the senseless and inexplicable violence of this act is somehow made worse by that brief moment of doubt. As the murderer walks away to the sound of Jules Massenet's opera *Werther* blaring out of his car radio, there is no sense of catharsis or resolution. And then, the events are repeated again, and again, and again. The actors become sweaty and tired. The light changes as we move from dawn to dusk. The events are repeated seventy times over thirteen hours. As the scene is re-enacted, the viewer's attention begins to take in other details in the narrative – the changing weather, subtle modifications in the actors' appearance, the passage of time, the oppressive architecture of the white house in the background. Assaulted daily with images of violence that often remain unexplained and devoid of any context, Claerbout's *White House* punctures our passive reception of these images and compels us to look again and, perhaps, get beyond the transient events of the present. Repeating its violent narrative seemingly endlessly, the work explores the relationship between trauma and memory – the way our minds act to transform a trauma in the immediate present, which we register but are unable to process – into an experience or memory that is eventually processed and stored and therefore can be retrieved as a way to make sense of the present.

[3]
Shadows of Empire
As the shadows lengthen across the white house of Claerbout's work, the house itself becomes a kind of sundial that registers the gradual and progressive passage of time. The shadows in turn become a kind of metaphor for the way in which history repeats itself, a theme explored in **Kara Walker**'s disturbing new film *8 Possible Beginnings...or the Creation of African America* (2006). Shadows have long been a tool for artists either to create a heightened sense of reality, to show what lies outside the immediate field of vision, or to manipulate the perception of people and objects through the subtle transformation of the shadows they cast. Mirroring the style of the earliest silent films at the turn of the twentieth century and even earlier fantastic shows of demons and hobgoblins in the sixteenth century, Walker presents a dark, episodic narrative, punctuated by slavery, rape and lynching.

Walker is the impresario and puppet master whose cut-out figures enact this brutally vivid, short history of African America in eight parts. Putting aside the artifice of illusion and filmmaking, Walker appears as a protagonist/puppeteer in her own film, manipulating the strings of her puppets through the violent contortions of African American experience. There is something deeply disquieting about Walker's use of puppetry, shadow play and the silent film genre to narrate these chronicles. A form of entertainment now associated with children, but historically associated with the representation of evil spirits and demons, Walker's film is a re-casting of American history through the prism of the nightmare experiences of African Americans.

Kara Walker's use of chiaroscuro in many ways echoes **Orson Welles**'s formal innovations and

experimental strategies in film and theatre, which were crystallised in his Mercury production company. Working with John Houseman (Director of the W.P.A.'s Negro Theatre Project), Welles produced his own version of *Macbeth* in 1936 at the Lafayette Theatre in Harlem in New York with an all African-American cast. Relocated to nineteenth-century Haiti, Welles's production of the play, which became known as *Voodoo Macbeth*, was inspired by the nineteenth-century Haitian king Henri Christophe and his cruel regime, which provoked a revolt and culminated in his suicide. By setting the play on an island in the Caribbean in the 1800s, Welles was able to invoke the forces of darkness, substituting voodoo priestesses for Shakespeare's witches and using drums throughout the play which sound the threat of violence and corruption. Welles was fascinated by the moral ambiguity of powerful men whose fantasies and delusions lead them to create autocratic empires that bear the seeds of their own demise (a fascination he was to pursue some years later in his film *Citizen Kane*, based on the life of the media tycoon William Randolph Hearst). Produced in the mid-1930s, during the same period when Walker Evans was photographing decaying plantation houses in the Deep South, Welles's *Voodoo Macbeth* has to be seen also in the context of the threat of fascism and impending war on the other side of the Atlantic. A political allegory of sorts, *Voodoo Macbeth* gave voice to fears about the disturbing and malign political forces that had gripped parts of Europe.

Almost forty years later, **Walker Evans** visited England (a confirmed Anglophile, Evans had visited England on previous occasions and taken photographs there). During this particular visit in August 1973, two years before his death, the photographer came to visit his long-standing friends Robert Lowell and Caroline Blackwood. Uncharacteristically

intimate, many of Evans's photographs from this trip are personal records of his friends at home in London and on the South coast, but among the private snapshots are also images that reflect Evans's distinctive preoccupations. Interspersed between the photographs of various examples of English architecture, from Georgian squares in London, Tudor-style cottages, country houses and the distinctive seaside buildings of Brighton, including the Palace Pier and Royal Pavilion, are tell-tale traces of Britain's imperial past and present. Evans's eye homes in, for example, on posters on a London news-stand reporting the discovery of an IRA bomb factory, on a palm tree silhouetted against the minarets of the Royal Pavilion, or on a poster advertising an exhibition about 'The British In India'. This latter sign appears in a photograph of Xandra Bingley (the first wife of the Anglo-Irish Lord Grey Gowrie) of whom Evans took several portraits. Xandra was a friend of Caroline Blackwood, a maverick member of the Guinness family whose great-grandfather, Lord Dufferin, had been Viceroy of India. 'London Bomb Factory Found' reads the headline for the Evening Standard, recorded by Evans alongside the Evening News's newspaper hoarding: 'Stock Exchange Bomb Blast Casualties'. Arriving in Britain one year after the events of Bloody Sunday in which thirteen demonstrators had been shot by British troops in the Bogside District of Londonderry, Evans's trip took place in the midst of an intensive and prolonged bombing campaign by the IRA on the British mainland. Not surprisingly, then, his photographs document an English landscape, which, like Evans's American South, is littered with evidence of a past that continues to impose itself on the present.

The English landscape is also the subject of **Henna Nadeem**'s work, which is installed in the gallery of

31

Charleston Farmhouse, the former home of Vanessa Bell and Duncan Grant. Conscientious objectors to World War I, Bell and Grant moved to the countryside from London in 1916 and began living at Charleston in the rolling Sussex Downs. Over a period of half a century Charleston became the country meeting place for the group of artists, writers and intellectuals known as the Bloomsbury Group including the novelist E. M. Forster, economist Maynard Keynes and art historian Roger Fry. Presenting a selection of works made for her artist's book *A Picture Book of Britain* (2006), Nadeem has created delicate and playful collages, using as her source material photographs of the British landscape, originally published by Country Life Magazine between the 1930s and 80s in a series of popular publications entitled the *Picture Books of Britain,* which from 1957 turned to super-real colour reproduction. Whereas the Country Life images were intended to evoke the essential character of the British nation and its timeless landscape, Nadeem's collages suggest a familiar but anonymous place, shrouded and screened by cut-out pattern templates drawn from a variety of non-Western sources. These patterns, which the artist uses to digitally blend the original Country Life images together, significantly alter the recognisable contours of the English countryside, and provide a mechanism for subtly combining two very different and opposed visual traditions. In the resulting works Nadeem creates a new hybrid pictorial space that eclipses its primary sources.

Projected outwards on to the main thoroughfare of central Brighton which separates the University of Brighton Gallery from the site of the Royal Pavilion buildings is **Adel Abdessemed**'s video work *God is Design* (2005), accompanied by a specially-commissioned score by Silvia Ocougne. Made up of 3,050 individual drawings that come

Walker Evans
(Xandra Bingley)
1973

33

one after the other in quick succession, *God is Design* is an animated film which appropriates a number of visual motifs and references from cells in the human body, through Jewish and Islamic religious symbols to Western geometric painting and North African abstract patterns in a collision of codes and styles. The individual elements of Abdessemed's animated film move so rapidly from one to the other that it is difficult to isolate or fix upon any distinct motif to the exclusion of another. Recalling his earlier work *The Green Book,* an artist's book for which Abdessemed invited a number of people of different nationalities to write down the lyrics of their national anthem in their own hand, *God is Design* assembles an array of signs and symbols to build a kind of visual Esperanto, which subtly effaces any single regime of signification.

[4]

Prologue to Madness

'There is a symbol to be found in the Forbidden City; this centre of the centre of the world. Locked inside was the emperor, direct link to the heaven, ruler and upholder of the Chinese empire, and simultaneously its prisoner. Locked outside was the world. A culture is always a palace and a prison. The migrant – I – must deal with questions of being inside or outside.'[11]

In the gardens of the Royal Pavilion, after sunset, **Fiona Tan**'s film *A Lapse of Memory* (2006) imagines a solitary and lonely man shut up in the Pavilion, who talks to himself constantly, unable to discern past from present, reality from fiction. Henry is an eccentric, living in voluntary exile and completely oblivious to his luxurious and extravagant surroundings. It is unclear whether his rantings are the hallucinations of an opium eater or the effects of senile dementia. Henry's identity is equally uncertain. Projected close by the distinctive architectural forms of the palace and its Indian-inspired minarets, Tan's film exposes to public view the interior of the Royal Pavilion as well as the condition of Henry's disturbed mind, as confused as the ostentatious décor of the building with its hybrid quotation of Indian, Chinese and Japanese styles. Like the protagonists of Dostoevsky's *Notes from Underground* and Ralph Ellison's *Invisible Man*, Tan's eccentric old man has been shaped irrevocably by the culture from which he is a recluse and which, perhaps, has been the cause of his delusions. Like Avedon's portraits of patients at East Louisiana Mental Hospital, Tan's work makes manifest those things usually hidden from public gaze. It is these unrepresented and, in some ways 'unrepresentable' aspects of culture and society

Henna Nadeem
From *A Picture Book of Britain,* 2006

11 From 'May You Live in Interesting Times',
documentary film, (Fiona Tan, 1997)

34

that Avedon and Tan disclose. Against the grain of the ubiquitous iconography of national and cultural identity, both artists have sought to represent what is usually perceived to be 'beyond representation' and to rupture those comforting representations of national culture with disquieting images. It is the capacity to hold in one's mind the gulf between the self one invents and the undiscoverable self which, according to Baldwin, is the only way for the individual and the nation to keep in touch with reality: 'It is perfectly possible – indeed, it is far from uncommon – to go to bed one night, or wake up one morning, or simply to walk through a door one has known all one's life, and discover, between inhaling and exhaling, that the self one has sewn together with such effort is all dirty rags, is unusable, is gone: and out of what raw material will one build a self again? The lives of men – and, therefore, of nations – to an extent literally unimaginable, depend on how vividly this question lives in the mind. It is a question which can paralyze the mind, of course; but if the question does NOT live in the mind, then one is simply condemned to eternal youth, which is a synonym for corruption'.[12]

[5]

Fantasy, Identity and Celebrity Culture
It is hard to tell from **William Eggleston**'s photographs whether Elvis Presley's Graceland mansion on the outskirts of Memphis, Tennessee is a palace or a prison. However, viewed through the curved iron gates – composed of musical notes hanging on metal bars which wrap around the estate – Presley's Memphis home does seem more like the latter, more a sugar-coated prison than a pleasure palace. Eggleston was commissioned in 1983 to document the singer's home, which had become a shrine and site of pilgrimage for fans of the American legend. A fellow Southerner (both Eggleston and Presley came from Mississippi), Eggleston's intense dye transfers of Presley's luxurious home (a sharp contrast to his humble beginnings in a shack in Tupelo) paint a very different picture of the South to the bleak, monochrome poverty which Evans and others had recorded almost fifty years earlier on behalf of the Farm Security Administration. The saturated colour photographs probe into the corners of Graceland's interior spaces, falling on different objects from the brash and bizarre rooms of the house. The trophies that fill Graceland suggest a garish opulence at the apex of the American dream's material accumulation: a gold piano, fur rugs and cushions, statuettes of classical Greek figurines and exotic animals, and portraits of the 'King' and his child bride. And in the corner of a sitting room, hung with gold drapes, is a small statuette of a cowboy, resting on a white television set. This palace, like the Royal Pavilion, Brighton, is dedicated to bolstering the celebrity and mythical status of the Memphis King, a shrine to fantasy, myth-making and the American dream.

12 Baldwin, op. cit.

William Eggleston
Untitled, Memphis, Tennessee, 1984
From the Portfolio: *William Eggleston's Graceland*

36

Van Leo
Self-Portrait, 1942

Growing up as a young man in Cairo, at the heart of the largest movie industry in the Middle East, the Armenian-Egyptian photographer **Van Leo** was obsessed with cinema, and particularly with Hollywood and its screen icons. From an early age, he collected cinema magazines and photographs of Hollywood stars, storing up a mental archive of images of glamour and celebrity. Van Leo would eventually establish his own photographic studio and create portraits of singers, actors, dancers and socialites that evoke the elegant and cosmopolitan lifestyle of Egyptian high society in the mid-twentieth century and its unruffled pursuit of leisure. But in the early 1940s, in the midst of the Second World War when he had set up a makeshift studio in his parents' apartment, Van Leo's primary subject was himself. During this time he made hundreds of self-portraits that depict the photographer variously as prisoner, woman, bohemian, air-force pilot, Cossak prince, or in different film roles from *femme fatale* to gangster, from Sam Spade to Zorro, allowing Van Leo to indulge his fascination with fantasy, games and make-believe. Taken in pre-revolutionary Cairo and during the last years of the British occupation of Egypt, Van Leo's images are self-absorbed and narcissistic but at the same time, he is intensely aware of the means of representation: several photographs portray him against the backdrop of his own images or holding the camera or camera lighting equipment or reflected in a mirror. One series of self-portraits depicts him in a number of different poses with a marble statue of an eighteenth-century woman: Van Leo embraces her, puts his arms around her, holds her tightly as if to kiss her, adjusts her shawl around her shoulders. At a time of massive social upheaval in Egypt and in the Middle East as a whole, Van Leo's extraordinary self-portraits, which stretched the conventions of studio photography

37

in his time, can variously be read as a means of turning away from the conflict and turmoil in the world around him into a world of illusion and make-believe which he could control and manipulate, or as a reflection of the multiple possibilities which faced a country like Egypt as it considered future post-war political scenarios – whether monarchist, colonial, Islamic or modern democratic.

[6]
The Limits of Photography

As artist-in-residence at the Design Council Archives, **Gabriel Kuri**'s intervention *As selected for the Design Centre London* (2006), presented across a number of public spaces in Brighton, moves photography quite literally out of the archive and into the public arena. Taking as his starting point a pristine image from 1962 of domestic tableware, Kuri's work reflects on the immaculate and unsoiled pictorial aesthetic that was characteristic not only of the Design Council's post-war photography but also of an era of unbridled enthusiasm for modernity and progress. Reclaimed from local second hand shops forty years after they had been launched into the marketplace as paragons of Britain's brave new world of modern design, the artist has installed identical sets of tableware in glass showcases in different sites across the city, three-dimensional simulcra of the original. Unlike the immaculate original, however, these three-dimensional replicas bear the traces of human consumption. Small stains and remnants of food have been left behind, evidence of the less than perfect domestic world that the Council's photography so emphatically ignored. Kuri's representations are like three-dimensional photographs that have broken out of their two-dimensional frames and entered everyday life. No longer spotless and pristine, Kuri's reproductions take the image of 1960s design idyll to its logical conclusion, bringing it into public circulation and usage. Keen to take forward the educational spirit of the Design Council's founding mission, Kuri's work completes the modernist project 'with human imperfection.'[13]

There is a single photographic image in **Alfredo Jaar**'s new installation *The Sound of Silence* (2006) and even this one image is only visible on the screen for a matter of seconds. When you enter Jaar's installation,

13 Unpublished correspondence with the artist, 2006.

you enter a story: it is a story about an individual photograph and its impact, but also a story about representation and its unequal effects. As the artist says: 'It is a lamentation. It's a poem that asks about the ethics of what we (photojournalists) do when we shoot pain.'[14] Characteristically, Jaar is as concerned with why and how something is represented as much as with what is represented. Although photography is central to his practice, Jaar's installations and public interventions cannot be defined by a particular medium or format. The aesthetic strategies he employs are based on responses to particular lived experiences, which he describes as a 'series of exercises in representation.' Jaar's work frequently exposes the limits of photographic representation in the face of cataclysmic events, notably the genocide in Rwanda, which cannot be invoked purely through traditional pictorial means. Instead Jaar's installations confront us with the inadequacy of photography as a vehicle for mediating human experience in any literal way.

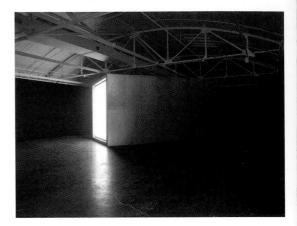

Access to *The Sound of Silence* is carefully controlled. As you enter the installation space, you are confronted with an unsettling narrative that again raises questions about what can and should be represented and of the responsibilities not only of the individual photographer but also of those who control the circulation and dissemination of the photographic image:
He positioned himself for the best possible image.
He waited 20 minutes. He was hoping the vulture would spread its wings. But it did not. He took his photographs. And chased the bird away. He watched as the little girl resumed her struggle. He sat under a tree and lit a cigarette. Talked to God. And cried. Kevin. Kevin.[15]

Jaar's work asks us searching questions about photography's political implications. In a context

14 Alfredo Jaar quoted by Patricia.
C. Johnson in the *Houston Chronicle*, March 17, 2006
15 Text from Alfredo Jaar,
The Sound of Silance, 2006

Alfredo Jaar
The Sound of Silence, 2006
Installation view

39

where reality television shows and web-casting purport to democratise the means of representation, Jaar's practice is a timely reminder of the gulf that exists between representation in a political sense with its attendant expectations of power, civil liberties and freedom of speech and the democratisation of the media which allows for greater individual participation but stops short of enabling us to be agents of significant change.

Separated by four decades, Jaar's *The Sound of Silence* and Avedon and Baldwin's *Nothing Personal*, nonetheless share a common desire to create a space for reflection and critique that stands apart from the representations of Hollywood, television, politics and the media. And it is this critical, creative space that allows us to disentangle fact from fiction, and illusion from reality. It is also the space that can potentially unlock the past so that it isn't endlessly replayed over and over again in the present. As Baldwin writes, 'When a civilisation treats its poets with the disdain with which we treat ours, it cannot be far from disaster; it cannot be far from the slaughter of the innocents'.[16]

The final image in *Nothing Personal* is shot in Atlanta, Georgia. A smartly dressed group of young people of different ages, both black and white, some holding placards, look directly at the camera. They are members of the Student Non-violent Co-ordinating Committee of Atlanta and have an air of quiet determination about them, a confidence in their capacity to bring about change.

A quiet storm had been brewing in the American South now for several years. Ever since the landmark ruling on segregation in May 1954 by the Supreme Court in the Brown vs the Board of Education of Topeka, Kansas, the Civil Rights struggle in America had entered a new phase. It was followed by the Montgomery bus boycott in which a young Reverend Martin Luther King Jnr had led black residents in Montgomery, Alabama in a boycott of public buses over a year and then in 1957 by the case of Little Rock High School in Arkansas where black children had to be accompanied into school by American paratroops to avoid mob violence from white segregationists.

The group in Avedon's photograph recalls the thirteen black and white young people who in May 1961 embarked on a Freedom Ride from Washington DC to New Orleans, travelling on Greyhound and Trailways buses to challenge segregation on public transport in the Deep South. Following in the footsteps of Martin Luther King's strategy of non-violent protest, the Student Non-Violent Co-ordinating Committee of Alabama appear to be the vanguard for massive social and economic change. The photograph, like the book as a whole, can be read as a call to action, an invocation to change rather than to murder.

For nothing is fixed, forever and forever and forever, it is not fixed; the earth is always shifting, the light is always changing, the sea does not cease to grind down rock. Generations do not cease to be born, and we are responsible to them because we are the only witnesses they have.[17]

16 Baldwin, op. cit.

17 Baldwin, op. cit.

Nothing Personal
James Baldwin

[I]

I used to distract myself, some mornings before I got out of bed, by pressing the television remote control gadget from one channel to another. This may be the only way to watch TV: I certainly saw some remarkable sights. Blondes and brunettes and, possibly, redheads–my screen was colorless–washing their hair, relentlessly smiling, teeth gleaming like the grill work of automobiles, breasts firmly, chillingly encased–packaged, as it were–and brilliantly uplifted, forever, all sagging corrected, forever, all middle age bulge–MIDDLE AGE BULGE!–defeated, eyes as sensuous and mysterious as jelly beans, lips covered with cellophane, hair sprayed to the consistency of aluminum, girdles forbidden to slide up, stockings defeated in their subversive tendencies to slide down, to turn crooked, to snag, to run, to tear, hands prevented from aging by incredibly soft detergents, fingernails forbidden to break by superbly smooth enamels, teeth forbidden to decay by mysterious chemical formulas, all conceivable body odor, under no matter what contingency, prevented for twenty-four hours of every day, forever and forever and forever, children's bones knit strong by the foresight of vast bakeries, tobacco robbed of any harmful effects by the addition of mint, the removal of nicotine, the presence of filters and the length of the cigarette, tires which cannot betray you, automobiles which will make you feel proud, doors which cannot slam on those precious fingers or fingernails, diagrams illustrating– proving–how swiftly impertinent pain can be driven away, square-jawed youngsters dancing, other square-jawed youngsters, armed with guitars, or backed by bands, howling; all of this–and so much more!–punctuated by the roar of great automobiles, overtaking gangsters, the spatter of tommy-guns mowing them down, the rise of the organ as the Heroine braces herself to Tell All, the moving smile of the housewife who has just won a fortune in metal and crockery; news–news? from where?–dropping into this sea with the alertness and irrelevancy of pebbles, sex wearing an aspect so implacably dispiriting that even masturbation (by no means mutual) seems one of the possibilities that vanished in Eden, and murder one's last, best hope–sex of an appalling coyness, often in the form

Richard Avedon
Joe Louis, prize fighter,
New York City, October 3, 1963

42

of a prophylactic cigarette being extended by the virile male toward the aluminum and cellophane girl. They happily blow smoke into each other's face, jelly beans, brilliant with desire, grillwork gleaming; perhaps–poor, betrayed exiles–they are trying to discover if, behind all that grillwork, all those barriers, either of them has a tongue.

Subsequently, in the longer and less explicit commercials in which these images are encased, the male certainly doesn't seem to have a tongue–perhaps one may say that the cat's got it; father knows best, these days, only in politics, which is the only place we ever find him, and where he proves to be–alas!–absolutely indistinguishable from the American boy. He doesn't even seem much closer to the grave–which fact, in the case of most of our most influential politicians, fills a great many people, all over the world, with despair.

And so it should. We have all heard the bit about what a pity it was that Plymouth Rock didn't land on the Pilgrims instead of the other way around. I have never found this remark very funny. It seems wistful and vindictive to me, containing, furthermore a very bitter truth. The inertness of that rock meant death for the Indians, enslavement for the blacks, and spiritual disaster for those homeless Europeans who now call themselves Americans and who have never been able to resolve their relationship either to the continent they fled or to the continent they conquered. Leaving aside–as we, mostly, imagine ourselves to be able to do–those people to whom we quaintly refer as minorities, who, without the most tremendous coercion, coercion indistinguishable from despair, would ever have crossed the frightening ocean to come to this desolate place? I know the myth tells us that heroes came, looking for freedom; just as the myth tells us that America is full of smiling people. Well, heroes are always, by definition, looking for freedom, and no doubt a few heroes got here, too–one wonders how they fared; and though I rarely see anyone smiling here, I am prepared to believe that many people are, though God knows what it is they're smiling about; but the relevant truth is that the country was settled by a desperate, divided, and rapacious horde of people who were determined to forget their pasts and determined to make money. We certainly have not changed in this respect and this is proved by our faces, by our children, by our absolutely unspeakable loneliness, and the spectacular ugliness and hostility of our cities. Our cities are terribly unloved–by the people who live in them, I mean. No one seems to feel that the city belongs to him.

Despair: perhaps it is this despair which we should attempt to examine if we hope to bring water to this desert.

It is, of course, in the very nature of a myth that those who are its victims and, at the same time, its perpetrators, should, by virtue of these two facts, be rendered unable to examine the myth, or even to suspect, much less recognize, that it is a myth which controls and blasts their lives. One sees this, it seems to me, in great and grim relief, in the situation of the poor white in the Deep South. The poor white was enslaved almost from the instant he arrived on these shores, and he is still enslaved by a brutal and cynical oligarchy. The

43

utility of the poor white was to make slavery both profitable and safe and, therefore, the germ of white supremacy which he brought with him from Europe was made hideously to flourish in the American air. Two world wars and a world-wide depression have failed to reveal to this poor man that he has far more in common with the ex-slaves whom he fears than he has with the masters who oppress them both for profit. It is no accident that ancient Scottish ballads and Elizabethan chants are still heard in those dark hills–talk about a people being locked in the past! To be locked in the past means, in effect, that one has no past, since one can never assess it, or use it: and if one cannot use the past, one cannot function in the present, and so one can never be free. I take this to be, as I say, the American situation in relief, the root of our unadmitted sorrow, and the very key to our crisis.

It has always been much easier (because it has always seemed much safer) to give a name to the evil without than to locate the terror within. And yet, the terror within is far truer and far more powerful than any of our labels: the labels change, the terror is constant. And this terror has something to do with that irreducible gap between the self one invents–the self one takes oneself as being, which is, however, and by definition, a provisional self–and the undiscoverable self which always has the power to blow the provisional self to bits. It is perfectly possible–indeed, it is far from uncommon–to go to bed one night, or wake up one morning, or simply walk through a door one has known all one's life, and discover, between inhaling and exhaling, that the self one has sewn together with such effort is all dirty rags, is unusable, is gone: and out of what raw material will one build a self again? The lives of men–and, therefore, of nations–to an extent literally unimaginable, depend on how vividly this question lives in the mind. It is a question which can paralyze the mind, of course; but if the question does NOT live in the mind, then one is simply condemned to eternal youth, which is a synonym for corruption.

Some rare days, often in the winter, when New York is cheerfully immobilized by snow– cheerfully, because the snow gives people an excuse to talk to each other, and they need, God help us, an excuse–or sometimes when the frozen New York spring is approaching, I walk out of my house toward no particular destination, and watch the faces that pass me. Where do they come from? how did they become–these faces–so cruel and so sterile? they are related to whom? they are related to what? They do not relate to the buildings, certainly–no human being could; I suspect, in fact, that many of us live with the carefully suppressed terror that these buildings are about to crash down on us; the nature of the movement of the people in the streets is certainly very close to panic. You will search in vain for lovers. I have not heard anyone singing in the streets of New York for more than twenty years. By singing, I mean singing for joy, for the hell of it. I don't mean the drunken, lonely, 4-am keening which is simply the sound of some poor soul trying to vomit up his anguish and gagging on it. Where the people can sing, the poet can live–and it is worth saying it the other way around, too: where the poet can sing, the people can live. When a

44

civilization treats its poets with the disdain with which we treat ours, it cannot be far from disaster; it cannot be far from the slaughter of the innocents. Everyone is rushing, God knows where, and everyone is looking for God knows what–but it is clear that no one is happy here, and that something has been lost. Only, sometimes, uptown, along the river, perhaps, I've sometimes watched strangers here, here for a day or a week or a month, or newly transplanted, watched a boy and a girl, or a boy and a boy, or a man and a woman, or a man and a child, or a woman and a child; yes, THERE was something recognizable, something to which the soul responded, something to make one smile, even to make one weep with exultation. They were yet distinguishable from the concrete and the steel. One felt that one might approach them without freezing to death.

[2]

A European friend of mine and myself were arrested on Broadway, in broad daylight, while looking for a taxi. He had been here three days, had not yet mastered English, and I was showing him the wonders of the city of New York. He was impressed and bewildered, though he also seemed rather to wonder what purpose it served–when, suddenly, down from heaven, or up through the sidewalk, two plain-clothes men appeared, separated us, scarcely a word was spoken. I watched my friend, carried by the scruff of the neck, vanish into the crowd. Not a soul seemed to notice; apparently it happened every day. I was pushed into the doorway of a drugstore, and frisked, made to empty my pockets, made to roll up my sleeves, asked what I was doing around here–"around here" being the city in which I was born.

I am an old hand at this–policemen have always loved to pick me up and, sometimes, to beat me up–so I said nothing during this entire operation. I was worried about my friend, who might fail to understand the warmth of his reception in the land of the free; worried about his command of English, especially when confronted by the somewhat special brand used by the police. Neither of us carried knives or guns, neither of us used dope: so much for the criminal aspect. Furthermore, my friend was a married man, with two children, here on a perfectly respectable visit, and he had not even come from some dirty and disreputable place, like Greece, but from geometric and solvent Switzerland: so much for morals. I was not exactly a bum, either, so I wondered what the cop would say.

He seemed extremely disappointed that I carried no weapons, that my veins were not punctured–disappointed, and, therefore, more truculent than ever. I conveyed to him with some force that I was not precisely helpless and that I was perfectly able, and more than willing, to cause him a great deal of trouble. Why, exactly, had he picked us up?

He was now confused, afraid, and apologetic, which caused me to despise him from the bottom of my heart. He said–how many times have I heard it!–that there had been a call out to pick up two guys who looked just like us.

White and black, you mean?

45

Apart from my friends, I think I can name on the fingers of one hand all the Americans I have ever met who were able to answer a direct question, a real question: well, not exactly. Hell, no. He hadn't even known that the other guy was white. (He thought that he was Puerto Rican, which says something very interesting, I think, about the eye of the beholder–like, as it were, to like.)

Nevertheless, he was in a box–it was not going to be a simple matter of apologizing and letting me go. Unless he was able to find his friend and MY friend, I was going to force him to arrest me and then bring charges for false arrest. So, not without difficulty, we found my friend, who had been released and was waiting in the bar around the corner from our house. He, also, had baffled his interlocutor; had baffled him by turning out to be exactly what he had said he was, which contains its own comment, I think, concerning the attitudes Americans have toward each other. He had given my friend a helpful tip: if he wanted to make it in America, it would be better for him not to be seen with niggers. My friend thanked him warmly, which brought a glow, I should imagine, to his simple heart–how we adore simplicity!–and has since made something of a point of avoiding white Americans.

I certainly can't blame him. For one thing, talking to Americans is usually extremely uphill work. We are afraid to reveal ourselves because we trust ourselves so little. American attitudes are appalling, but so are the attitudes of most of the people in the world. What is stultifying here is that the attitude is presented as the person; one is expected to justify the attitude in order to reassure the person–whom, alas, one has yet to meet, who is light-years away, in some dreadful, private labyrinth. And in this labyrinth the person is desperately trying NOT to find out what he REALLY feels. Therefore, the truth cannot be told, even about one's attitudes: we live by lies. And not only, for example, about race– whatever, by this time, in this country, or, indeed, in the world, this word may mean–but about our very natures. The lie has penetrated to our most private moments, and the most secret chambers of our hearts.

Nothing more sinister can happen, in any society, to any people. And when it happens, it means that the people are caught in a kind of vacuum between their present and their past–the romanticized, that is, the maligned past, and the denied and dishonored present. It is a crisis of identity. And in such a crisis, at such a pressure, it becomes absolutely indispensable to discover, or invent–the two words, here, are synonyms–the stranger, the barbarian, who is responsible for our confusion and our pain. Once he is driven out–destroyed–then we can be at peace: those questions will be gone. Of course, those questions never go, but it has always seemed much easier to murder than to change. And this is really the choice with which we are confronted now.

I know that these are strong words for a sunlit, optimistic land, lulled for so long, and into such an euphoria, by prosperity (based on the threat of war) and by such magazines as READER'S DIGEST, and stirring political slogans, and Hollywood and television. (Communications whose role is not to communicate, but simply to reassure.) Nevertheless,

I am appalled–for example–by the limpness with which the entire nation appears to have accepted the proposition that, in the city of Dallas, Texas, in which handbills were being issued accusing the late President Kennedy of treason, one would NEED a leftist lunatic with a gun to blow off the President's head. Leftists have a hard time in the south; there cannot be very many there; I, certainly, was never followed around southern streets by leftist lunatics, but state troopers. Similarly, there are a great many people in Texas, or, for that matter, in America, with far stronger reasons for wishing the President dead than any demented Castroite could have had. Quite apart, now, from what time will reveal the truth of this case to have been, it is reassuring to feel that the evil came from without and is in no way connected with the moral climate of America; reassuring to feel that the enemy sent the assassin from far away, and that we, ourselves, could never have nourished so monstrous a personality or be in any way whatever responsible for such a cowardly and bloody act. Well. The America of my experience has worshipped and nourished violence for as long as I have been on earth. The violence was being perpetrated mainly against black men, though–the strangers; and so it didn't count.

But, if a society permits one portion of its citizenry to be menaced or destroyed, then, very soon, no one in that society is safe. The forces thus released in the people can never be held in check, but run their devouring course, destroying the very foundations which it was imagined they would save.

But we are unbelievably ignorant concerning what goes on in our country–to say nothing of what goes on in the rest of the world–and appear to have become too timid to question what we are told. Our failure to trust one another deeply enough to be able to talk to one another has become so great that people with these questions in their hearts do not speak them; our opulence is so pervasive that people who are afraid to lose whatever they think they have persuade themselves of the truth of a lie, and help disseminate it; and God help the innocent here, that man or woman who simply wants to love, and be loved. Unless this would-be lover is able to replace his or her backbone with a steel rod, he or she is doomed. This is no place for love. I know that I am now expected to make a bow in the direction of those millions of unremarked, happy marriages all over America, but I am unable honestly to do so because I find nothing whatever in our moral and social climate–and I am now thinking particularly of the state of our children–to bear witness to their existence. I suspect that when we refer to these happy and marvellously invisible people, we are simply being nostalgic concerning the happy, simple, God-fearing life which we imagine ourselves once to have lived. In any case, wherever love is found, it unfailingly makes itself felt in the individual, the personal authority of the individual. Judged by this standard, we are a loveless nation. The best that can be said is that some of us are struggling. And what we are struggling against is that death in the heart which leads not only to the shedding of blood, but which reduces human beings to corpses while they live.

[3]

Four AM can be a devastating hour. The day, no matter what kind of day it was, is indisputably over; almost instantaneously, a new day begins: and how will one bear it? Probably no better than one bore the day that is ending, possibly not as well. Moreover, a day is coming which one will not recall, the last day of one's life, and on that day one will ONESELF become as irrecoverable as all the days that have passed.

It is a fearful speculation–or, rather, a fearful knowledge–that, one day one's eyes will no longer look out on the world. One will no longer be present at the universal morning roll call. The light will rise for others, but not for you. Sometimes, at four AM, this knowledge is almost enough to force a reconciliation between oneself and all one's pain and error. Since, anyway, it will end one day, why not try it–life–one more time? IT'S A LONG OLD ROAD, as Bessie Smith puts it, BUT IT'S GOT TO FIND AN END. And so, she wearily, doggedly, informs us, I PICKED UP MY BAG, BABY, AND I TRIED IT AGAIN. Her song ends on a very bitter and revealing note: YOU CAN'T TRUST NOBODY, YOU MIGHT AS WELL BE ALONE/ FOUND MY LONG-LOST FRIEND, AND I MIGHT AS WELL STAYED AT HOME!

Still, she was driven to find that long-lost friend, to grasp again, with fearful hope, the unwilling, unloving, human hand. I think all of our voyages drive us there; for I have always felt that a human being could only be saved by another human being. I am aware that we do not save each other very often. But I am also aware that we save each other some of the time. And all that God can do, and all that I expect Him to do, is lend one the courage to continue one's journey and face one's end, when it comes, like a man.

For, perhaps–perhaps–between now and that last day, something wonderful will happen, a miracle, a miracle of coherence and release. And the miracle on which one's unsteady attention is focused is always the same, however it may be stated, or however it may remain unstated. It is the miracle of love, love strong enough to guide or drive one into the great estate of maturity, or, put it another way, into the apprehension and acceptance of one's own identity. For some deep and ineradicable instinct–I believe–causes us to know that it is only this passionate achievement which can outlast death, which can cause life to spring from death.

Nevertheless, sometimes, at four AM, when one feels that one has probably become simply incapable of supporting this miracle, with all one's wounds awake and throbbing, and all one's ghastly inadequacy staring and shouting from the walls and the floor–the entire universe having shrunk to the prison of the self–death glows like the only light on a high, dark, mountain road, where one has, forever and forever! lost one's way.–And many of us perish then.

But if one can reach back, reach down–into oneself, into one's life–and find there some witness, however unexpected or ambivalent, to one's reality, one will be enabled, though perhaps not very spiritedly, to face another day. (We used to sing in the church, IT'S

ANOTHER DAY'S JOURNEY, AND I'M SO GLAD, THE WORLD CAN'T DO ME NO HARM!) What one must be enabled to recognize, at four o'clock in the morning, is that one has no right, at least not for reasons of private anguish, to take one's life. All lives are connected to other lives and when one man goes, much more than the man goes with him. One has to look on oneself as the custodian of a quantity and a quality–oneself–which is absolutely unique in the world because it has never been here before and will never be here again. But it is extremely difficult, in this place and time, to look on oneself in this way. Where all human connections are distrusted, the human being is very quickly lost.

Four AM passes, the dangerous turning maneuvered once more; and here comes the sun or the rain and the hard, metallic, unrevealing light and sounds of life outside and movement in the streets. Cautiously, one peeks through the blinds, guessing at the weather. And, presently, out of the limbo of the bathroom steam and fog, one's face comes floating up again, from unimaginable depths. Here it comes, unreadable as ever, the patient bones steady beneath the skin, eyes veiling the mind's bewilderment and the heart's loss, only the lips cryptically suggesting that all is not well with the spirit which lives within this clay. Then one selects the uniform which one will wear. This uniform is designed to telegraph to others what to see so that they will not be made uncomfortable and probably hostile by being forced to look on another human being. The uniform must suggest a certain setting and it must dictate a certain air and it must also convey, however subtly, a dormant aggressiveness, like the power of a sleeping lion. It is necessary to make anyone on the streets think twice before attempting to vent his despair on you. So armed, one reaches the unloved streets. The unloved streets. I have very often walked through the streets of New York fancying myself a kind of unprecedented explorer, trapped among savages, searching for hidden treasure; the trick being to discover the treasure before the savages discovered me; hence, my misleading uniform. After all, I have lived in cities in which stone urns on park parapets were not unthinkable, cities in which it was perfectly possible, and not a matter of taking one's life in one's hands, to walk through the park. How long would a stone urn last in Central Park? And look at the New York buildings, rising up like tyrannical eagles, glass and steel and aluminum smiting the air, jerry-built, inept, contemptuous; who can function in these buildings and for whose profit were they built? Unloved indeed: look at our children. They roam the streets, as arrogant and irreverent as business-men and as dangerous as those gangs of children who roamed the streets of bombed European cities after the last World War. Only, these children have no strange and grinning soldiers to give them chocolate candy or chewing gum, and no one will give them a home. No one has one to give, the very word no longer conveying any meaning, and, anyway, nothing is more vivid in American life than the fact that we have no respect for our children, nor have our children any respect for us. By being what we have become, by placing things above people, we broke their hearts early, and drove them away.

We have, as it seems to me, a very curious sense of reality–or, rather, perhaps, I should

49

say, a striking addiction to irreality. How is it possible, one cannot but ask, to raise a child without loving a child? How is it possible to love the child if one does not know who one is? How is it possible for the child to grow up if the child is not loved? Children can survive without money or security or safety or things: but they are lost if they cannot find a loving example, for only this example can give them a touchstone for their lives. THUS FAR AND NO FURTHER: this is what the father must say to the child. If the child is not told where the limits are, he will spend the rest of his life trying to discover them. For the child who is not told where the limits are knows, though he may not know he knows it, that no one cares enough about him to prepare him for his journey.

This, I think, has something to do with the phenomenon, unprecedented in the world, of the ageless American boy; it has something to do with our desperate adulation of simplicity and youth—how bitterly betrayed one must have been in one's youth to suppose that it is a virtue to remain simple or to remain young!—and it also helps to explicate, to my mind at least, some of the stunning purposes to which Americans have put the imprecise science of psychiatry. I have known people in genuine trouble, who somehow managed to live with their trouble; and I cannot but compare these people—ex-junkies and jail-birds, sons of German Nazis, sons of Spanish generals, sons of Southern racists, blues singers and black matrons—with that fluid horde, in my professional and quasi-professional contacts, whose only real trouble is inertia, who work at the most disgraceful jobs in order to pay, for the luxury of someone else's attention, twenty-five dollars an hour. To my black and toughened, Puritan conscience, it seems an absolute scandal; and, again, this peculiar self-indulgence certainly has a dreadful effect on their children, whom they are quite unable to raise. And they cannot raise them because they have opted for the one commodity which is absolutely beyond human reach: safety. This is one of the reasons, as it seems to me, that we are so badly educated, for to become educated (as all tyrants have always known) is to become inaccessibly independent, it is to acquire a dangerous way of assessing danger, and it is to hold in one's hands a means of changing reality. This is not at all the same thing as "adjusting" to reality: the effort of "adjusting" to reality simply has the paradoxical effect of destroying reality, since it substitutes for one's own speech and one's own voice an interiorized public cacophony of quotations. People are defeated or go mad or die in many, many ways, some in the silence of that valley, WHERE I COULDN'T HEAR NOBODY PRAY, and many in the public, sounding horror where no cry or lament or song or hope can disentangle itself from the roar. And so we go under, victims of that universal cruelty which lives in the heart and in the world, victims of the universal indifference to the fate of another, victims of the universal fear of love, proof of the absolute impossibility of achieving a life without love. One day, perhaps, unimaginable generations hence, we will evolve into the knowledge that human beings are more important than real estate and will permit this knowledge to become the ruling principle of our lives. For I do not for an instant doubt, and I will go to my grave believing, that we can build Jerusalem, if we will.

[4]

THE LIGHT THAT'S IN YOUR EYES/ REMINDS ME OF THE SKIES/ THAT SHINE ABOVE US EVERY DAY–so wrote a contemporary lover, out of God knows what agony, what hope, and what despair. But he saw the light in the eyes, which is the only light there is in the world, and honored it and trusted it; and will always be able to find it; since it is always there, waiting to be found. One discovers the light in darkness, that is what darkness is for; but everything in our lives depends on how we bear the light. It is necessary, while in darkness, to know that there is a light somewhere, to know that in oneself, waiting to be found, there is a light. What the light reveals is danger, and what it demands is faith. Pretend, for example, that you were born in Chicago and have never had the remotest desire to visit Hong Kong, which is only a name on a map for you; pretend that some convulsion, sometimes called accident, throws you into connection with a man or a woman who lives in Hong Kong; and that you fall in love. Hong Kong will immediately cease to be a name and become the center of your life. And you may never know how many people live in Hong Kong. But you will know that one man or one woman lives there without whom you cannot live. And this is how our lives are changed, and this is how we are redeemed.

What a journey this life is! dependent, entirely, on things unseen. If your lover lives in Hong Kong and cannot get to Chicago, it will be necessary for you to go to Hong Kong. Perhaps you will spend your life there, and never see Chicago again. And you will, I assure you, as long as space and time divide you from anyone you love, discover a great deal about shipping routes, air lanes, earthquake, famine, disease, and war. And you will always know what time it is in Hong Kong, for you love someone who lives there. And love will simply have no choice but to go into battle with space and time and, furthermore, to win.

I know we often lose, and that the death or destruction of another is infinitely more real and unbearable than one's own. I think I know how many times one has to start again, and how often one feels that one cannot start again. And yet, on pain of death, one can never remain where one is. The light. The light. One will perish without the light.

I have slept on rooftops and in basements and subways, have been cold and hungry all my life; have felt that no fire would ever warm me, and no arms would ever hold me. I have been, as the song says, 'BUKED AND SCORNED and I know that I always will be. But, my God, in that darkness, which was the lot of my ancestors and my own state, what a mighty fire burned!

In that darkness of rape and degradation, that fine, flying froth and mist of blood, through all that terror and in all that helplessness, a living soul moved and refused to die. We really emptied oceans with a home-made spoon and tore down mountains with our hands. And if love was in Hong Kong, we learned how to swim.

51

It is a mighty heritage, it is the human heritage, and it is all there is to trust. And I learned this through descending, as it were, into the eyes of my father and my mother. I wondered, when I was little, how they bore it–for I knew that they had much to bear. It had not yet occurred to me that I also would have much to bear; but they knew it, and the unimaginable rigors of their journey helped them to prepare me for mine. This is why one must say Yes to life and embrace it wherever it is found–and it is found in terrible places; nevertheless, there it is; and if the father can say, YES, LORD, the child can learn that most difficult of words, AMEN.

For nothing is fixed, forever and forever and forever, it is not fixed; the earth is always shifting, the light is always changing, the sea does not cease to grind down rock. Generations do not cease to be born, and we are responsible to them because we are the only witnesses they have.

The sea rises, the light fails, lovers cling to each other, and children cling to us. The moment we cease to hold each other, the moment we break faith with one another, the sea engulfs us and the light goes out.

52

BRIGHTON MUSEUM & ART GALLERY
6 October 2006 – 7 January 2007

NOTHING PERSONAL
Richard Avedon
William Eggleston
Walker Evans
Paul Fusco
Richard Misrach
Andy Warhol

Central to this exhibition, which assembles historical and contemporary images by leading American photographers and artists, is *Nothing Personal*, a collaboration between photographer Richard Avedon and writer James Baldwin. First published in 1964, one year after the assassination of John F. Kennedy, the book presented a compelling and disturbing portrait of the Unites States of America, 'the heart, mind and soul of a troubled nation'. As relevant now as it was 40 years ago, *Nothing Personal* provokes questions about the state of the American nation and about the USA's current role on the world stage. Exhibited here with Avedon's disturbing and moving photographs are Walker Evans's haunting images of neglected plantation houses and Civil War monuments in the Deep South, William Eggleston's elegiac colour photographs of Elvis Presley's Graceland mansion, Andy Warhol's silkscreen prints from his *Electric Chair* series, Richard Misrach's monumental *Desert Cantos* and Paul Fusco's moving *RFK Funeral Train* photographs.

A Brighton Museum & Art Gallery Exhibition in association with Brighton Photo Biennial. Funded by Arts Council England.

Richard Avedon
*The Generals of the Daughters of the American
Revolution, DAR Convention, Mayflower
Hotel, Washington D.C., October 15, 1963*

Richard Avedon
*The Wedding of Mr and Mrs H.E. Kennedy,
New York City, April 29, 1961*

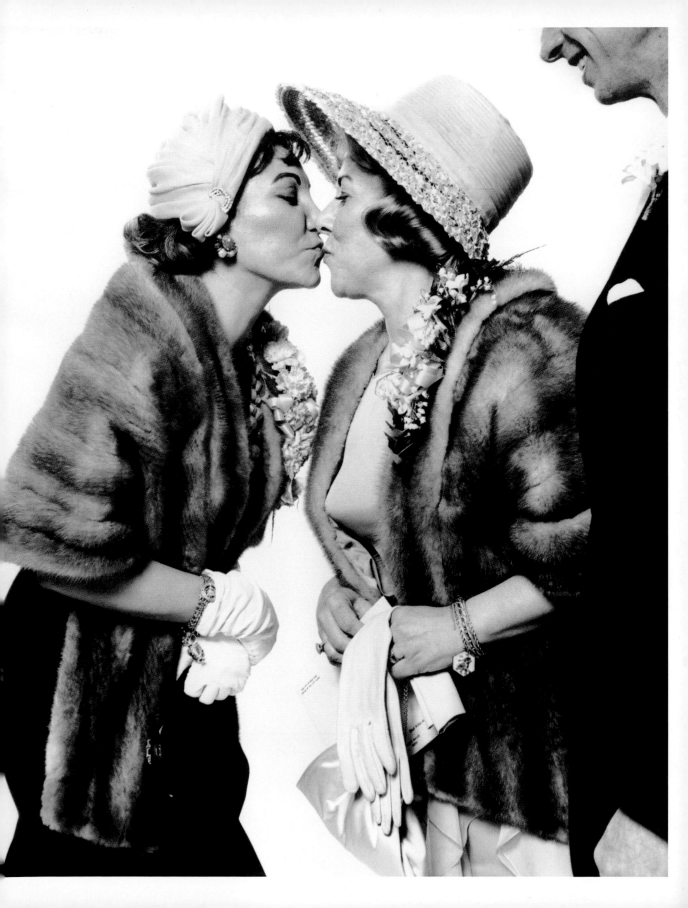

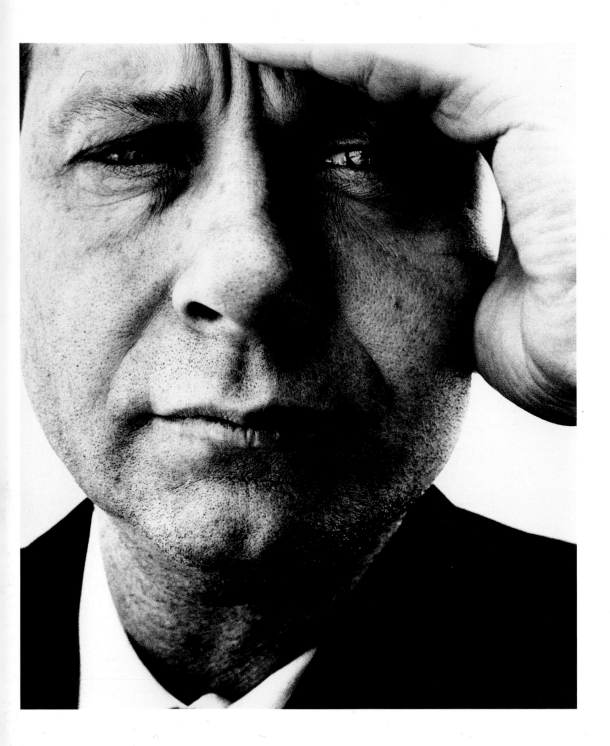

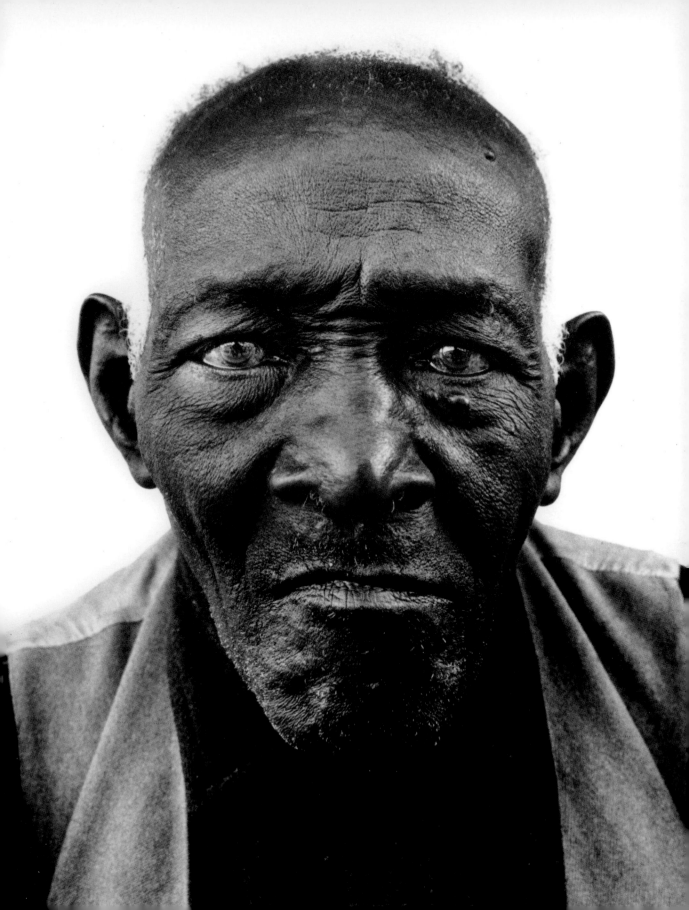

[pp.56-57]

Richard Avedon
Major Claude Eatherly, pilot at Hiroshima,
Galveston, Texas, April 3, 1963

Richard Avedon
William Casby, Born in Slavery,
Algiers, Louisiana, March 24, 1963

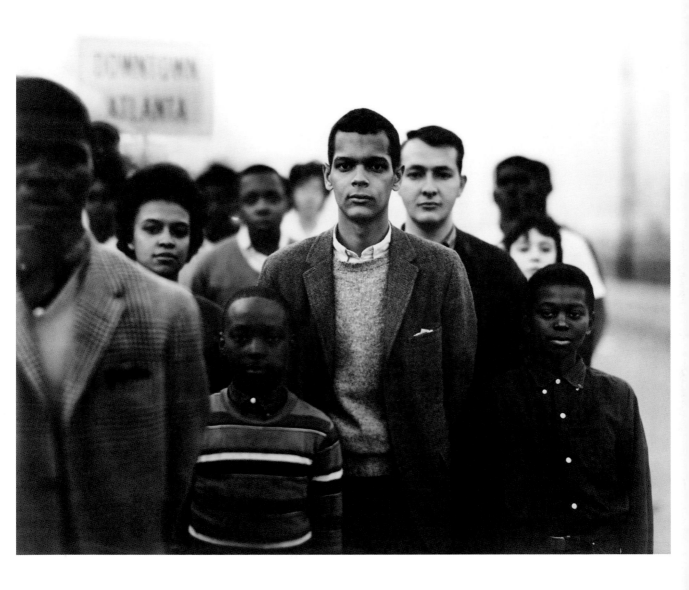

Richard Avedon
Student Non-Violent Coordinating
Committee, headed by Julian Bond,
Atlanta, Georgia, March 23, 1963

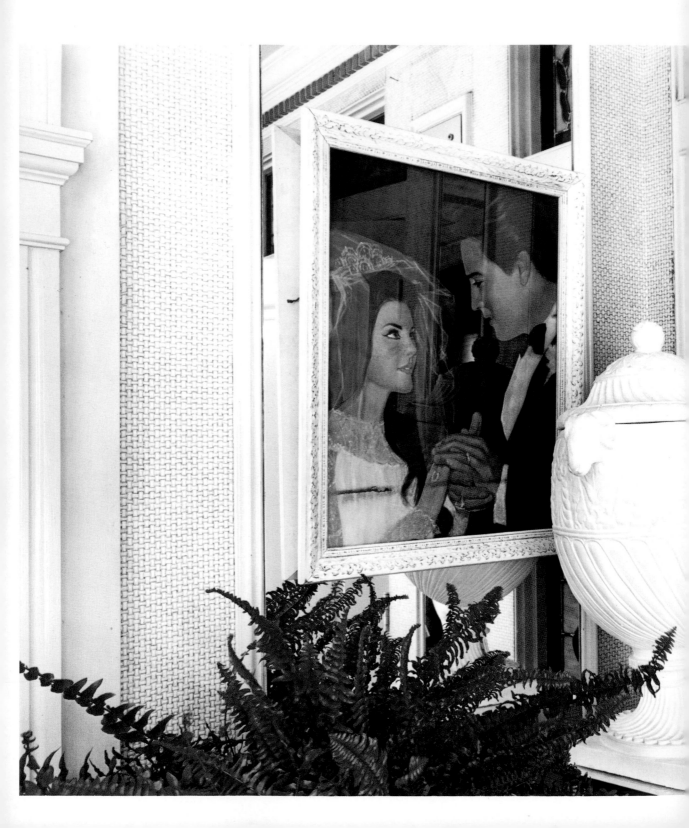

William Eggleston
Untitled, Memphis, Tennessee,
1984. From the Portfolio:
William Eggleston's Graceland

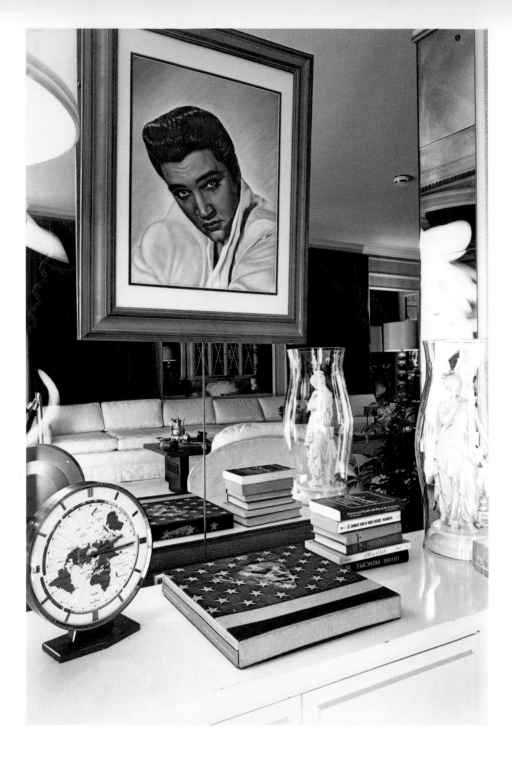

William Eggleston
Untitled, Memphis, Tennessee, 1984
From the Portfolio: *William Eggleston's Graceland*

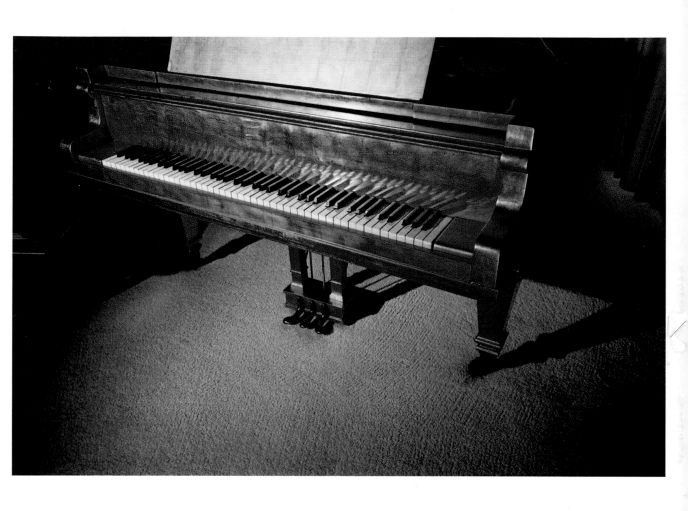

William Eggleston
Untitled, Memphis, Tennessee, 1984
From the Portfolio: *William Eggleston's Graceland*
[and pp.65-66]

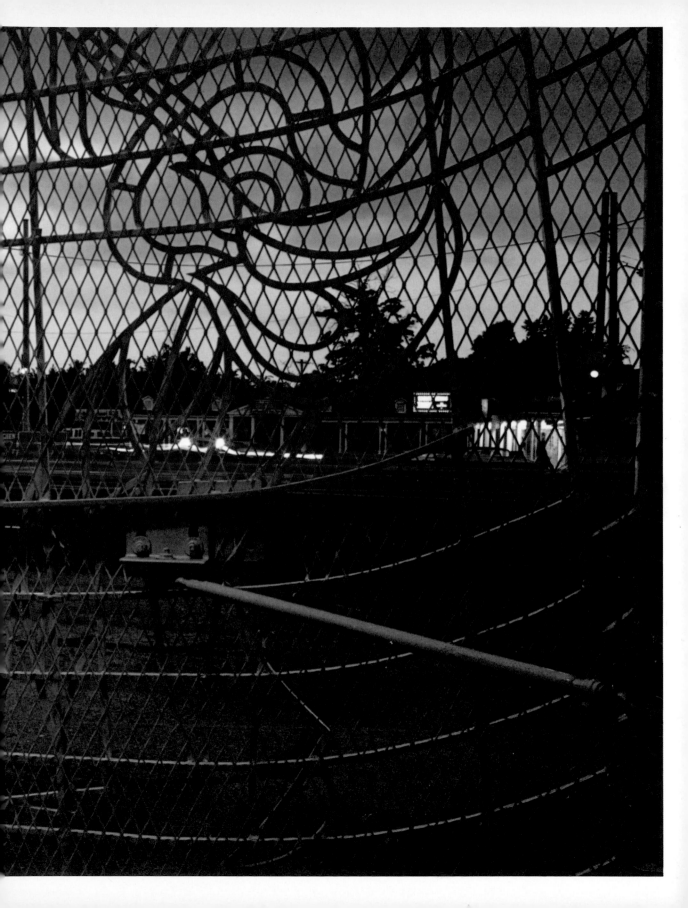

Andy Warhol
[no title]
Screenprint on paper, 1971

Andy Warhol
[no title]
Screenprint on paper, 1971

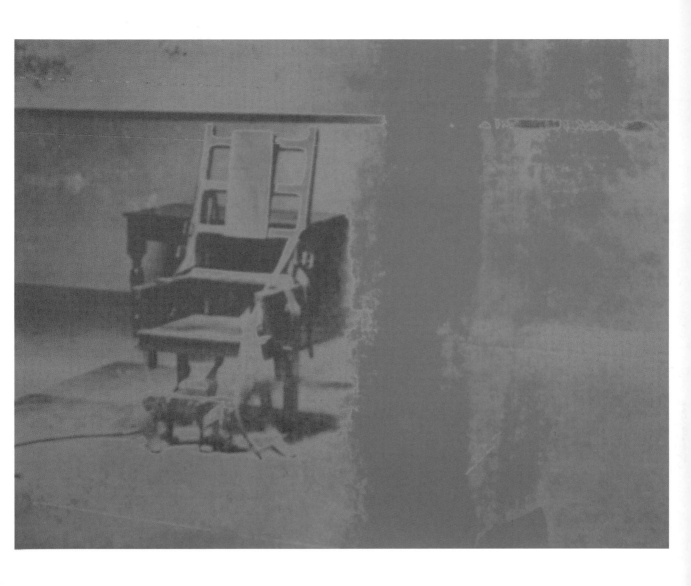

Andy Warhol
[no title]
Screenprint on paper, 1971

70

Andy Warhol
[no title]
Screenprint on paper, 1971

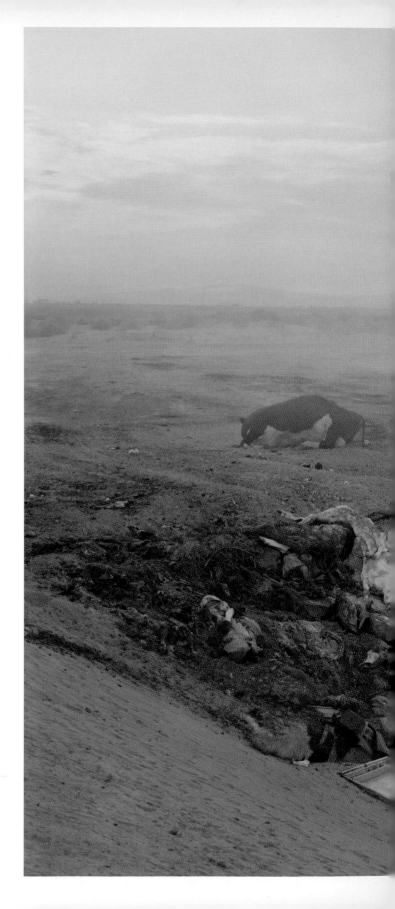

Richard Misrach
Dead Animals #93, Nevada,
from the series *The Pit*, 1987

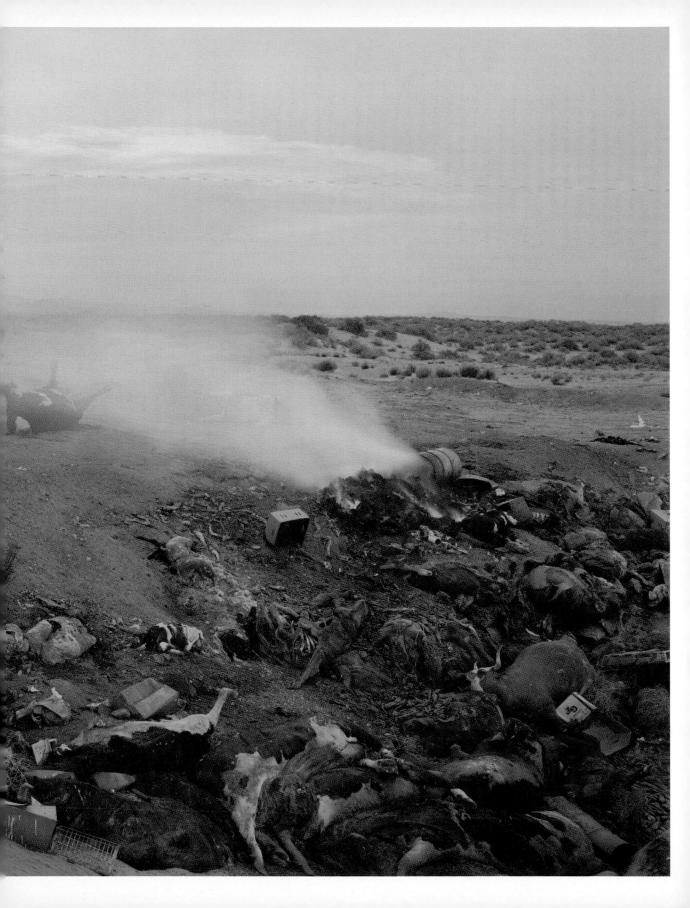

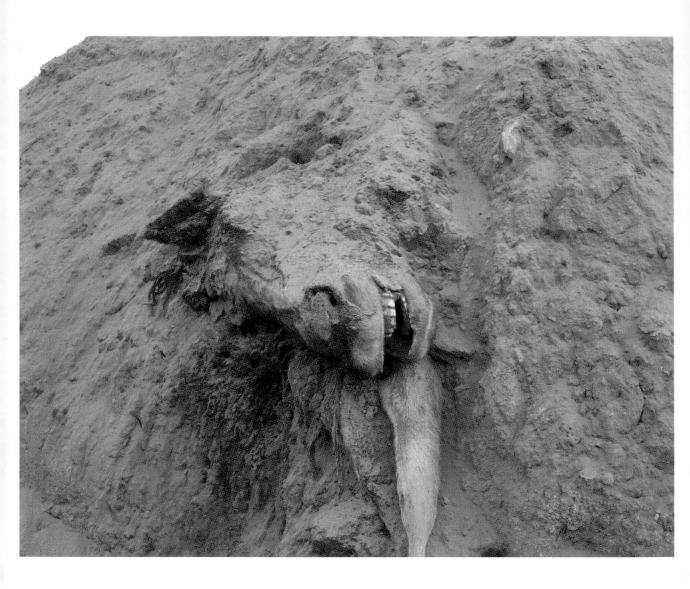

Richard Misrach
Dead Animals #327, Nevada,
from the series *The Pit*, 1987

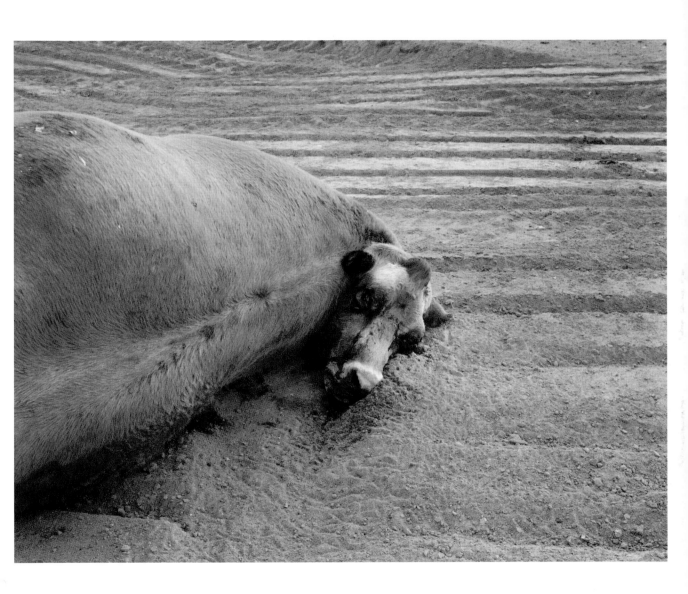

Richard Misrach
Dead Animals #454, Nevada,
from the series *The Pit*, 1987

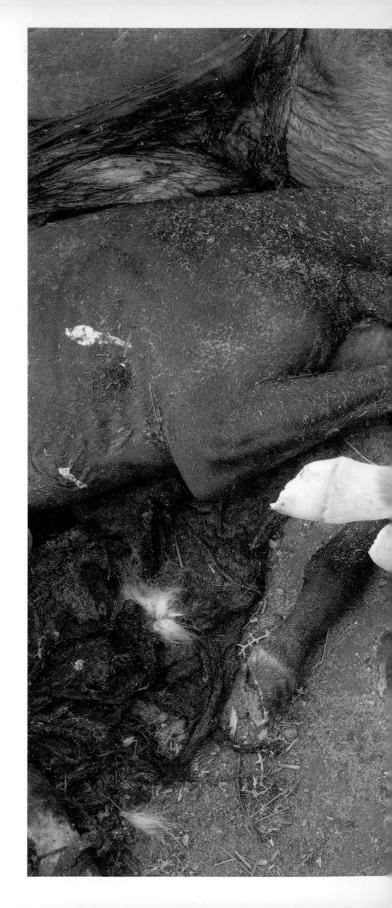

Richard Misrach
Dead Animals #79, Nevada,
from the series *The Pit*, 1987

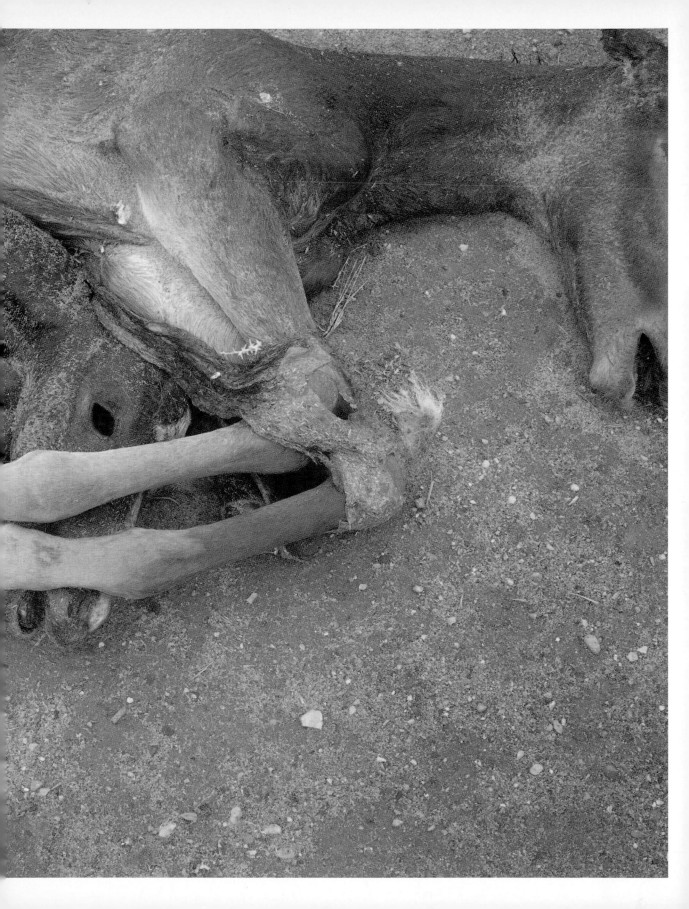

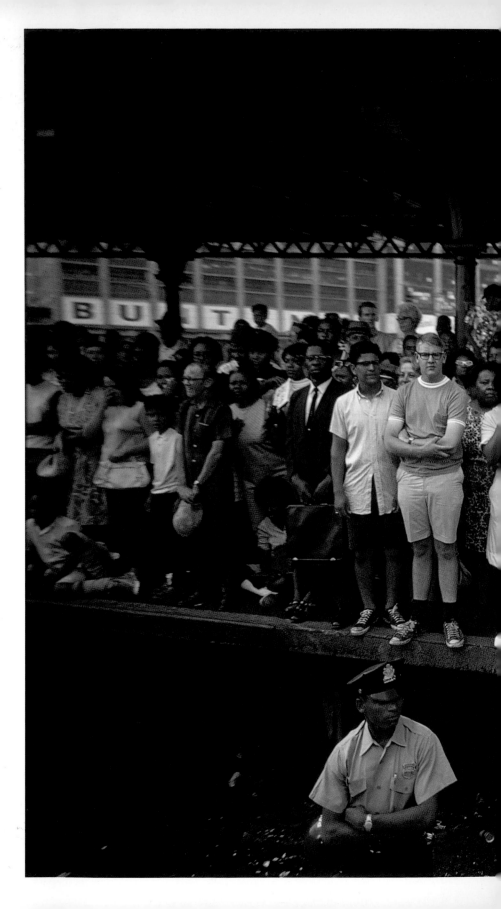

Paul Fusco
RFK Funeral Train
1968

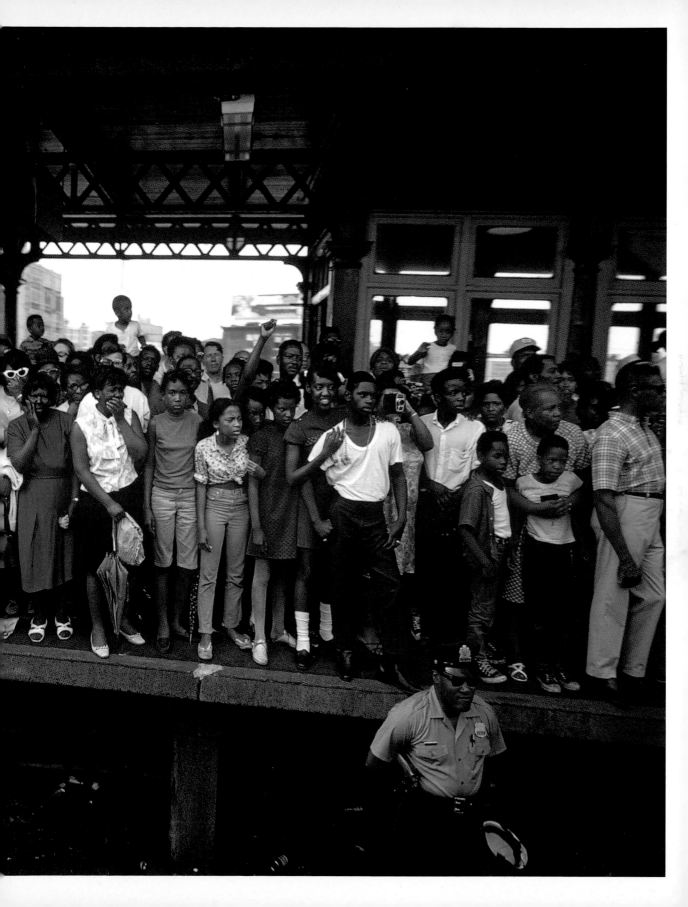

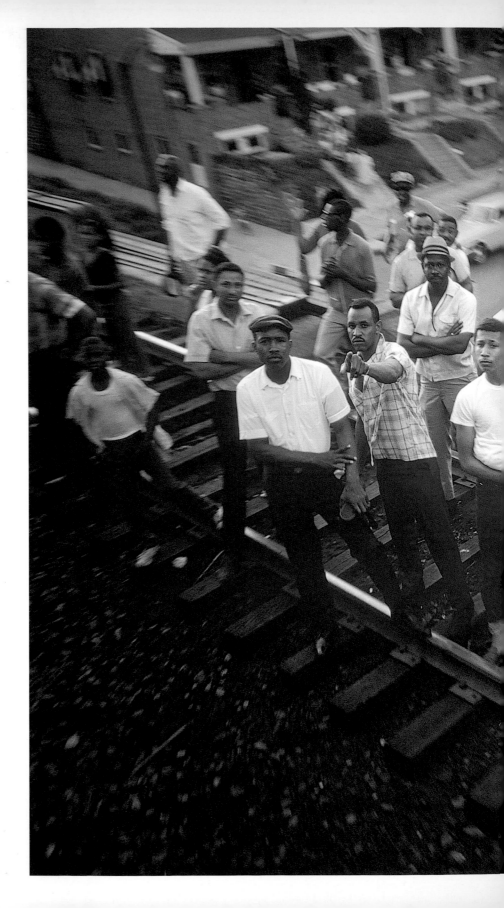

Paul Fusco
RFK Funeral Train
1968

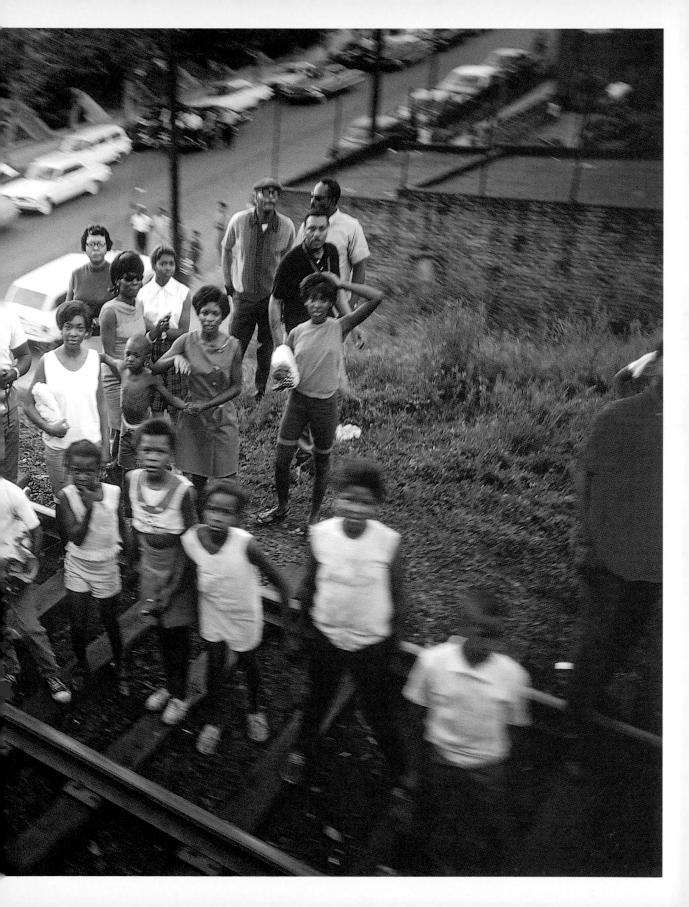

Paul Fusco
RFK Funeral Train
1968

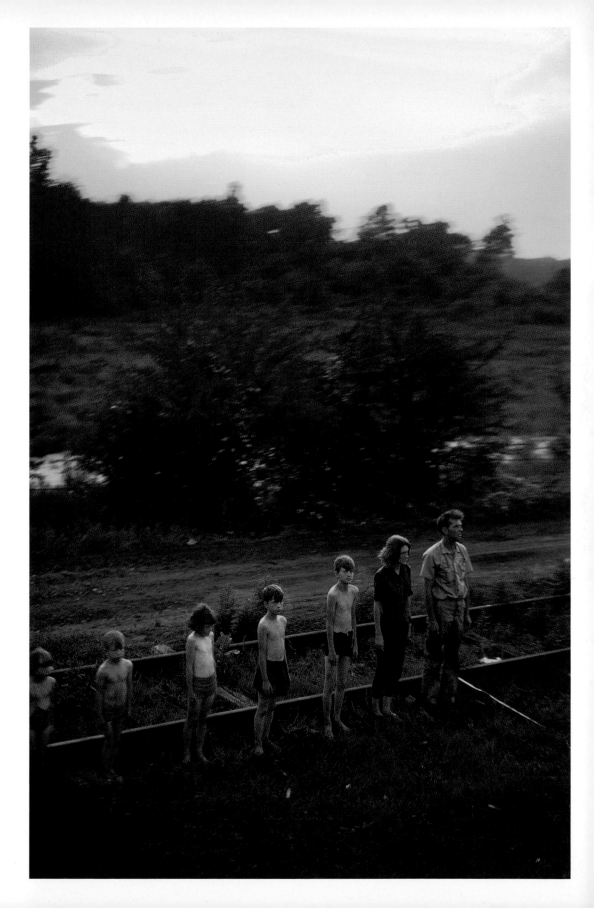

Walker Evans
*Vicksburg Battlefield Monument,
Mississippi,* 1936

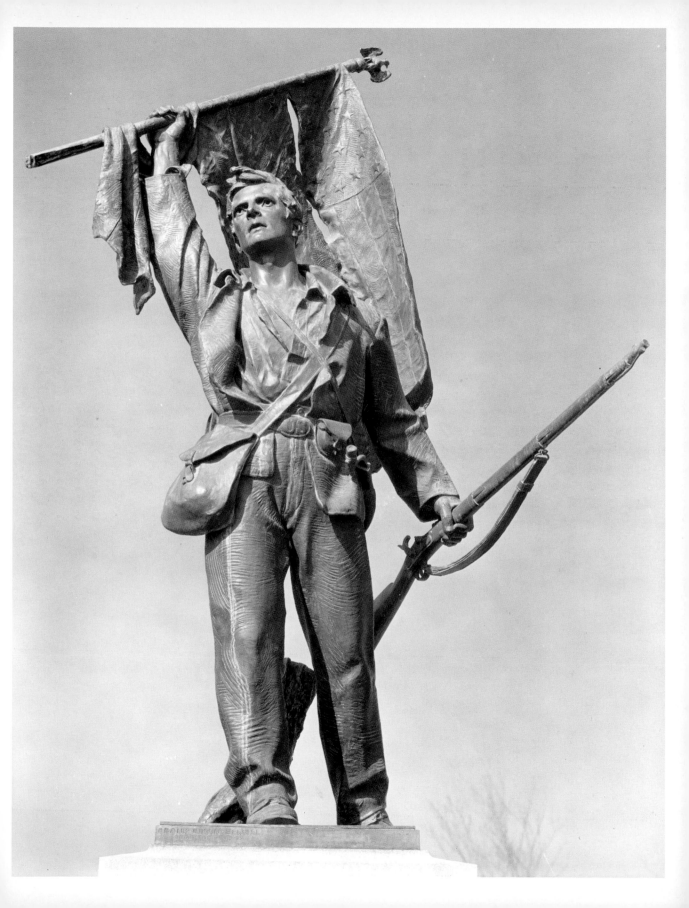

Walker Evans
Church Interior, Alabama, 1936

Walker Evans
Room in Louisiana Plantation House,
1935

ROYAL PAVILION GARDENS
6 October 2006 – 29 October 2006

A LAPSE OF MEMORY
Fiona Tan

Screening after sunset in the gardens of the Royal Pavilion is a newly commissioned film by Fiona Tan. *A Lapse of Memory* (2006) imagines a solitary and lonely man held captive in the Royal Pavilion who talks to himself constantly, unable to discern past from present, reality from fiction. Projected close by the distinctive architectural forms of the palace and its Indian-inspired minarets, Tan's film exposes to public view the interior of the Pavilion as well as its protagonist's disturbed mind.

A Lapse of Memory is a collaborative project by Royal Pavilion, Libraries & Museums; Brighton & Hove City Council; Brighton Photo Biennial and Screen Archive South East. It is funded by Arts Council England, South East; The Mondriaan Foundation; The Netherlands Film Funds and Frith Street Gallery, London and is part of the Brighton & Hove Arts Commission's making a difference initiative funded with lottery money from the Millennium Commission and Arts Council England through the Urban Cultural Programme. Fiona Tan is represented by Frith Street Gallery, London.

Fiona Tan
A Lapse of Memory, 2006
Artist's impression

Fiona Tan
A Lapse of Memory, 2006
Filmed in Royal Pavilion, Brighton.

Walker Evans
Room in Louisiana Plantation House,
1935

ROYAL PAVILION GARDENS
6 October 2006 – 29 October 2006

A LAPSE OF MEMORY
Fiona Tan

Screening after sunset in the gardens of the Royal Pavilion is a newly commissioned film by Fiona Tan. *A Lapse of Memory* (2006) imagines a solitary and lonely man held captive in the Royal Pavilion who talks to himself constantly, unable to discern past from present, reality from fiction. Projected close by the distinctive architectural forms of the palace and its Indian-inspired minarets, Tan's film exposes to public view the interior of the Pavilion as well as its protagonist's disturbed mind.

A Lapse of Memory *is a collaborative project by Royal Pavilion, Libraries & Museums; Brighton & Hove City Council; Brighton Photo Biennial and Screen Archive South East. It is funded by Arts Council England, South East; The Mondriaan Foundation; The Netherlands Film Funds and Frith Street Gallery, London and is part of the Brighton & Hove Arts Commission's making a difference initiative funded with lottery money from the Millennium Commission and Arts Council England through the Urban Cultural Programme. Fiona Tan is represented by Frith Street Gallery, London.*

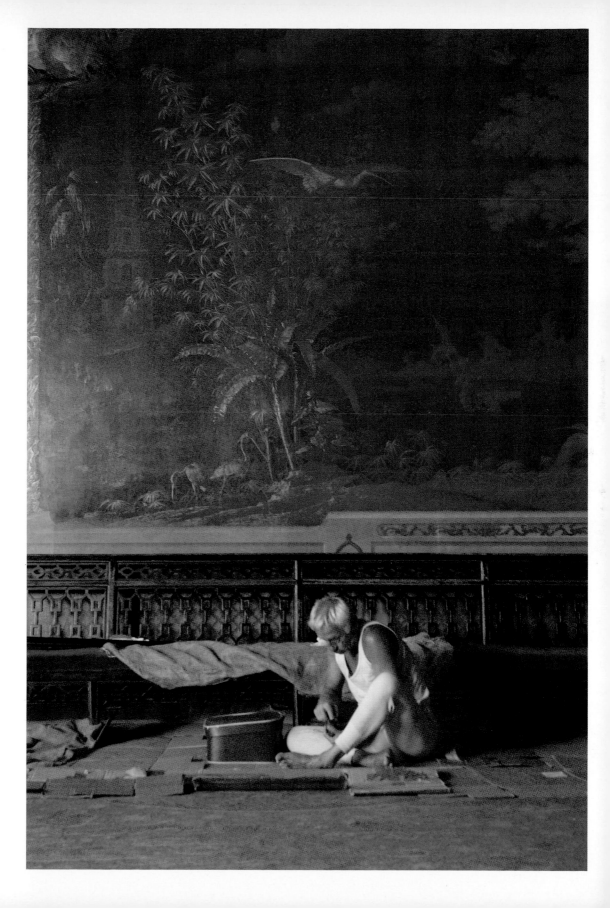

FABRICA
6 October 2006 – 5 November 2006

THE SOUND OF SILENCE
Alfredo Jaar

Fabrica, a contemporary art space located in a former Regency church, hosts the European premiere of Alfredo Jaar's *The Sound of Silence*. This is a dramatic new installation focusing on the life of South African photojournalist Kevin Carter. Jaar's installations and public interventions cannot be easily defined by a particular medium or format. The aesthetic strategies he employs are based on responses to particular lived experiences that the artist describes as a 'series of exercises in representation.' Jaar's work frequently exposes the limits of photographic representation in the face of cataclysmic events, notably the genocide in Rwanda, which cannot be invoked purely through traditional pictorial means.

A Fabrica Exhibition in association with Brighton Photo Biennial. Supported by The Henry Moore Foundation. Project part-financed by the European Union.

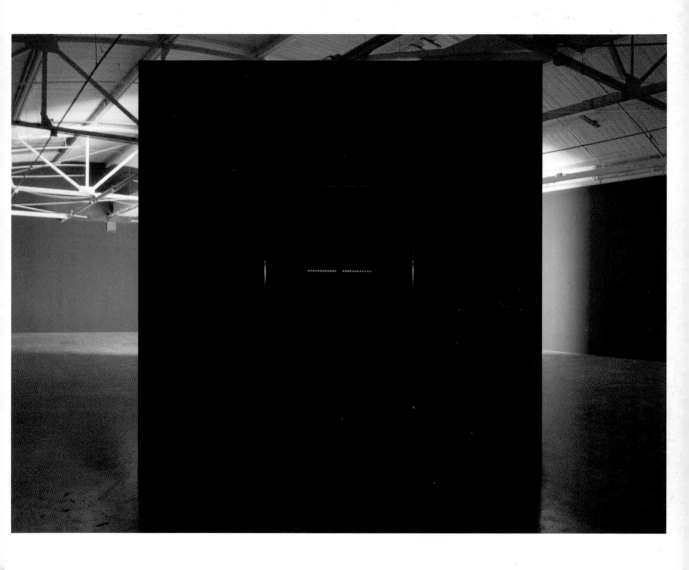

Alfredo Jaar
The Sound of Silence, 2006
Installation view

96

Alfredo Jaar
The Sound of Silence, 2006
Installation view and film stills

they took many risks

they were arrested many times

they were called the bang-bang club

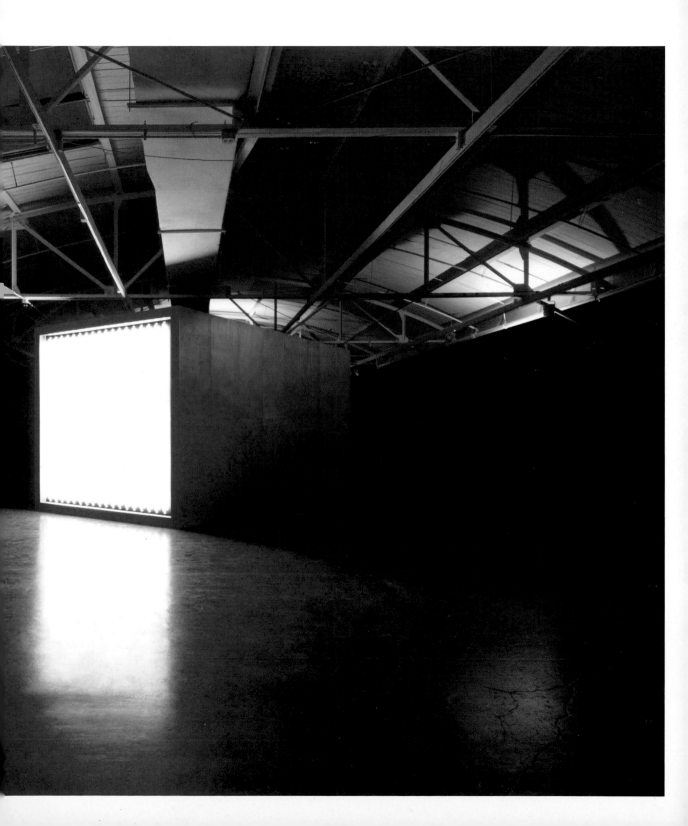

98

Alfredo Jaar
The Sound of Silence, 2006
Film stills

Alfredo Jaar
The Sound of Silence, 2006
Installation view

PUBLIC VENUES, BRIGHTON
6 October 2006 – 29 October 2006

AS SELECTED FOR THE DESIGN CENTRE LONDON
Gabriel Kuri

As artist-in-residence at the University of Brighton Design Archives, Gabriel Kuri's intervention *As Selected for the Design Centre London* in Brighton's civic spaces moves photography quite literally out of the archive and into the public arena. Taking as his starting point a pristine black and white image from 1956 of domestic tableware from the Design Council Archive, Kuri's work reflects on the immaculate and unsoiled pictorial aesthetic which was characteristic not only of the Design Council's post-war photography but also of an era of unbridled enthusiasm for modernity and progress. This project has been made possible thanks to an award from the Faculty Research Support Fund, Faculty of Arts & Architecture, University of Brighton.

A University of Brighton Design Archives Public Art Project in collaboration with Brighton Photo Biennial.

Gabriel Kuri
As Selected for the Design Centre London
2006

Gabriel Kuri
As Selected for the Design Centre London
2006

Gabriel Kuri
As Selected for the Design Centre London
2006

Gabriel Kuri
As Selected for the Design Centre London
2006

Gabriel Kuri
As Selected for the Design Centre London
2006

UNIVERSITY OF BRIGHTON GALLERY
6 October 2006 – 4 November 2006

WHITE HOUSE
David Claerbout

Antwerp-based artist David Claerbout presents a new work, *White House* (2006) at the University of Brighton Gallery. Lasting over thirteen hours and filmed in a single day, Claerbout's film shows two men engaged in a discussion against the back-drop of a neoclassical house in southern France. An act of violence is repeated and re-enacted seventy times over the course of the film. Dissolving the boundaries between photography and film, Claerbout's work puts into question the reassuring stillness of photography and the inevitable narrative progress of the cinematic image. His film and photography installations disorient the viewer by endowing still images with movement and by slowing or even halting the cinematic passage of time.

A University of Brighton Gallery Exhibition in association with Brighton Photo Biennial.

David Claerbout
White House, 2006
Single channel widescreen video projection,
colour, stereo, 13 hours 27 min
Film Stills
[and pp.108-111]

UNIVERSITY OF BRIGHTON GALLERY
6 October 2006 – 4 November 2006

SELF-PORTRAITS
Van Leo

Van Leo was an Armenian-Egyptian studio photographer, whose portraits of Egyptian cosmopolitan society evoke the glamour and flamboyance of 1950s pre-revolutionary Cairo, during the last years of the British occupation of Egypt. However, Van Leo's main subject was himself, and over fifty of his extraordinary self-portraits make up this exhibition at the University of Brighton Gallery. Having grown up in the largest movie industry in the Middle East, Van Leo created self-absorbed and narcissistic images that enabled him to play out different film roles, from *femme fatale* to gangster, from Sam Spade to Zorro. At a time of massive upheaval in Egypt and in the Middle East as a whole, Van Leo's extraordinary self-portraits could be seen as a reflection of the multiple possibilities that faced Egypt at a deeply uncertain moment in its political history.

A University of Brighton Gallery Exhibition in collaboration with Brighton Photo Biennial. Sponsored by Spectrum Photographic.

Van Leo
Self-Portrait 1946 *Self-Portrait* 1944

Self-Portrait 1945 *Self-Portrait* 1942

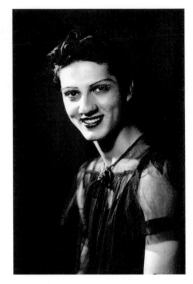

Van Leo

| *Self-Portrait* 1942 | *Self-Portrait* 1942 | *Self-Portrait* 1942 |
| *Self-Portrait* 1946 | *Self-Portrait* 1944 | *Self-Portrait* 1945 |

115

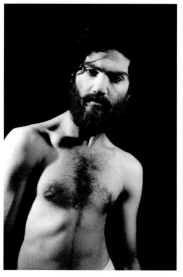
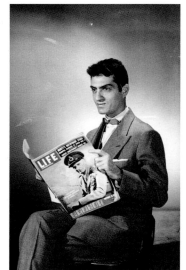
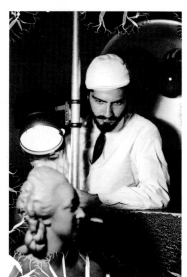

Van Leo
Self-Portrait 1942

Self-Portrait 1945

Self-Portrait 1948

Self-Portrait 1942

Self-Portrait 1958

Self-Portrait 1944

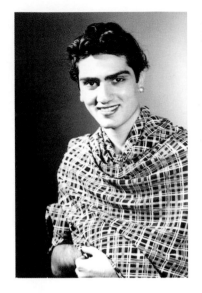

Van Leo

Self-Portrait 1942	*Self-Portrait* 1942	*Self-Portrait* 1939
Self-Portrait 1944	*Self-Portrait* 1942	*Self-Portrait* 1943

117

Van Leo

Self-Portrait 1942 *Self-Portrait* 1944 *Self-Portrait* 1941

Self-Portrait 1948 *Self-Portrait* 1942 *Self-Portrait* 1942

UNIVERSITY OF BRIGHTON GALLERY
6 October 2006 – 4 November 2006

GOD IS DESIGN
Adel Abdessemed

Adel Abdessemed's animated film *God is Design* (2005) is projected outwards on to the gallery's windows over Grand Parade, the main thoroughfare of central Brighton that separates the University of Brighton Gallery from the site of the Royal Pavilion buildings. Accompanied by a commissioned score by Silvia Ocougne, this resonant work appropriates a number of visual motifs and references, from cells in the human body, through Jewish and Islamic religious symbols to Western geometric painting and North African abstract patterns, brought together in a collision of codes and styles. Recalling his earlier work *The Green Book,* in which Abdessemed invited people of different nationalities to write down the lyrics of their national anthem in their own hand, *God is Design* builds a kind of visual Esperanto, which subtly eradicates any single regime of signs and symbols.

A University of Brighton Gallery Exhibition in association with Brighton Photo Biennial.

Adel Abdessemed
God is Design, 2005
Video projection

GARDNER ARTS CENTRE
6 October 2000 – 26 November 2006

ENGLAND, 1973
Walker Evans

The exhibition brings together, for the first time, a series of photographs that reveal a little-known chapter in the life of the great American photographer Walker Evans. Drawn from the Walker Evans Archive at New York's Metropolitan Museum of Art, these images record Evans's visit to England in 1973, two years before his death. Essentially an intimate, personal travelogue presented in the exhibition as a projected sequence, the photographs show Evans easing his way back into photography after a near-fatal operation the previous year. But among the images of his friends and the places he visited, including the Royal Pavilion, Brighton and the Palace Pier, are emphatic reminders of his peerless vision and his unwavering interest in architecture and signage, and in objects bearing the traces of age and use.

To accompany and contextualise the projected sequence, the exhibition also contains other unfamiliar Evans material, including photographs taken for the American Farm Security Administration in the 1930s and original 1950s editions of Fortune magazine which contain Evans's little known but remarkable colour photography.

A Photoworks Exhibition in association with Brighton Photo Biennial. Curated by Gilane Tawadros and Photoworks.

Walker Evans
(Royal Pavilion, Brighton)
1973

122

Walker Evans
(Palace Pier, Brighton)
1973

Walker Evans
(Palace Pier, Brighton)
1973

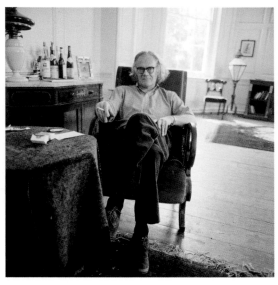

Walker Evans
(News-stand, London?)
1973

Walker Evans
(Robert Lowell at Milgate, Kent)
1973

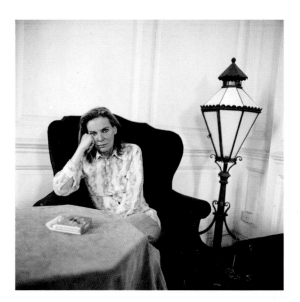

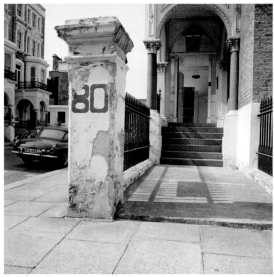

Walker Evans
(Caroline Blackwood at Milgate, Kent)
1973

Walker Evans
(Redcliffe Square, London)
1973

CHARLESTON FARMHOUSE
6 October 2006 – 29 October 2006

A PICTURE BOOK OF BRITAIN
Henna Nadeem

In the Bloomsbury Group's rural enclave at Charleston Farmhouse, Henna Nadeem shows her series of collaged photographs *A Picture Book of Britain*.

In this work Nadeem uses photographs from a series of highly popular books published between 1937 and the 1980s by Country Life, entitled the *Picture Books of Britain*. Nadeem has employed pattern templates derived from a variety of non-Western sources as a basis for grafting two kinds of images together.

Delicate and playful, Nadeem's collages suggest a familiar but anonymous landscape. Two very different visual traditions vie for prominence in a hybrid pictorial space that eclipses its primary sources.

Charleston Farmhouse was decorated in the distinctive style of Vanessa Bell and Duncan Grant. For over half a century Charleston became the country meeting place for the group of artists, writers and intellectuals known as Bloomsbury including the novelist E. M. Forster, economist Maynard Keynes and art historian Roger Fry.

Henna Nadeem: A Picture Book of Britain *is commissioned by Photoworks.*

A Photoworks Exhibition in association with Brighton Photo Biennial.

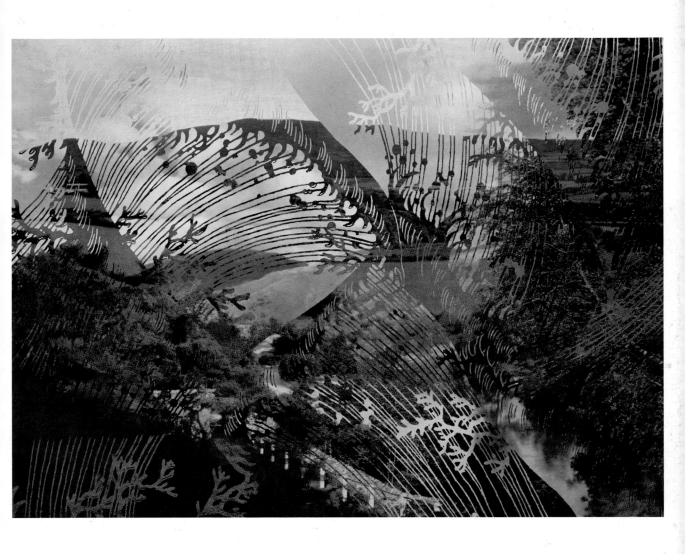

Henna Hadeem
From *A Picture Book of Britain*, 2006
[and pp.128-129]

DE LA WARR PAVILION, BEXHILL-ON-SEA
6 October 2006 – 7 January 2007
VOODOO MACBETH

Orson Welles's African-American theatre production of *Macbeth* forms the basis of a major exhibition, *Voodoo Macbeth*, at the iconic Modernist De La Warr Pavilion, Bexhill-on-Sea. The recently refurbished Pavilion was created at the same time as Welles's 1936 production, which relocated the play to nineteenth-century Haiti to comment on the threat of fascism and impending war. *Voodoo Macbeth* contains film footage and archive photographs of Welles's original production, plus screenings of the director's films and a video installation featuring his famous radio broadcast, *War of the Worlds*. The exhibition also features work and new commissions by contemporary international artists including Glenn Ligon, Phyllis Baldino, Mitra Tabrizian, Lee Miller, Kara Walker and Steve McQueen.

A De La Warr Pavilion Exhibition in association with Brighton Photo Biennial. Voodoo Macbeth is co-curated by David A. Bailey and Gilane Tawadros.

Mitra Tabrizian
Correct Distance
(a series of 4 triptychs), 1986
Each 20" x 24"

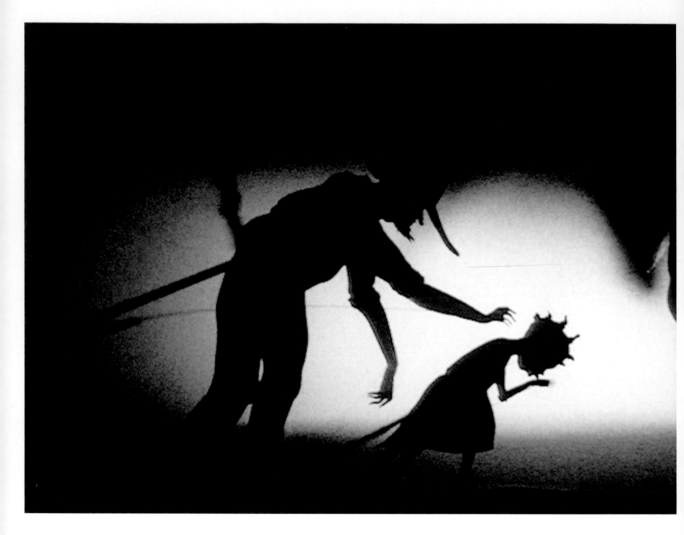

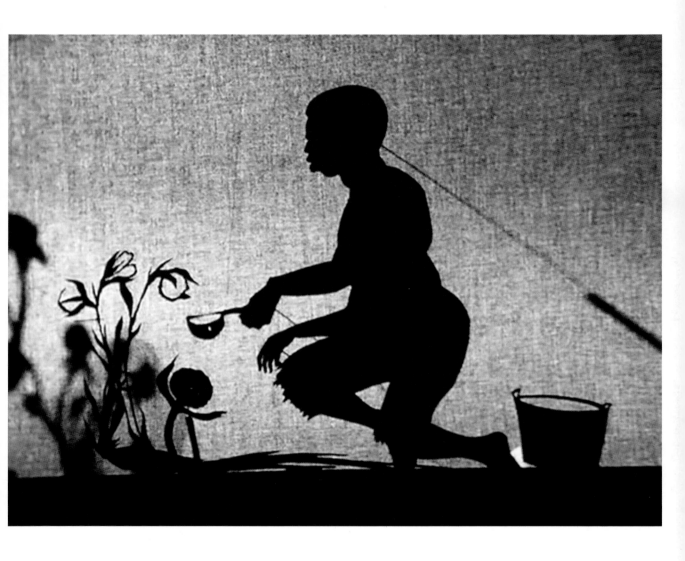

Kara Walker
*8 Possible Beginnings Or: The Creation
of African-America, Parts 1-8, A Moving
Picture By Kara E. Walker*, 2005
Duration 15min 57sec
Film Stills

136

[pp.36-37]
Macbeth Opening Night
Harlem, 1936

Phyllis Baldino
Mars/Rome/NY De La Warr, 2006
Two channel video installation
Left channel: 14min 22sec
Right channel: 9min 24sec
Video Stills

Phyllis Baldino
Mars/Rome/NY De La Warr, 2006
Two channel video installation
Left channel: 14min 22sec
Right channel: 9min 24sec
Video Stills

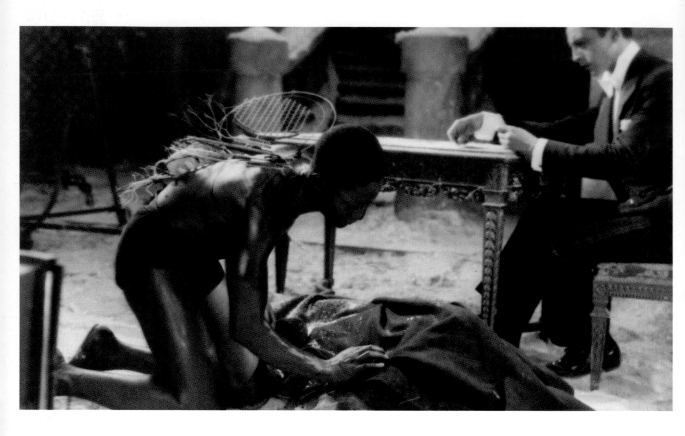

Feral Benga (leaning over body) in
Le Sang d'une Poete by Jean Cocteau.
Paris, 1930 (Photographer: Sacha Masour)

Lee Miller
Edward Matthews from *Four
Saints in Three Acts*, 1933

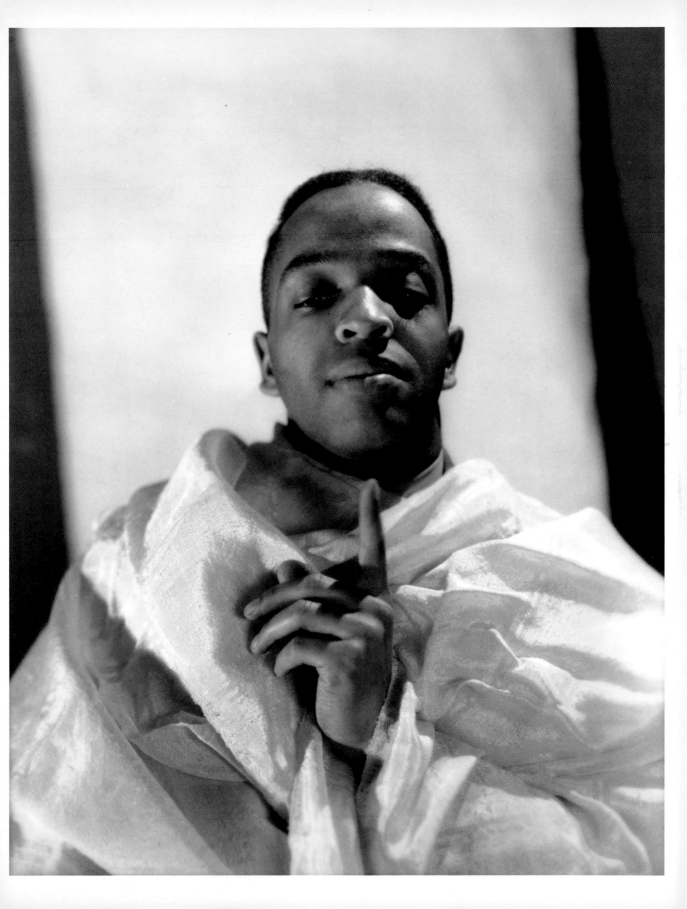

Glenn Ligon
Warm Broad Glow, 2005
Neon and Paint
Installation view

Steve McQueen
Charlotte, 2004
16mm film projection
Duration 7min
Film still

Brighton Photo Biennial Education initiates and manages a continuous programme of projects that encourage a wide and diverse range of people to enjoy, engage with and participate in photographic practice. The Biennial aims to create audiences for photography through a series of artist-led projects developed in partnership with local arts, education and community organisations, as well as with the University of Brighton's undergraduate courses. Collaboration is at the heart of the Biennial's education strategy, ensuring that partnerships inform practice, maximise potential, broaden opportunities and engage appropriate professional expertise in order to deliver high quality creative projects that match partners' and participants' needs.

Key education partners are the University of Brighton, where the Biennial office is based, enabling it to occupy a central location within the higher education community, and the Brighton-based specialist agency Photoworks, which ensures that the Biennial maintains and fosters direct links with Brighton's thriving photographic community. Through its education activities, the Biennial maintains a year round presence in Brighton & Hove and its activities recognise the unique economic, demographic and cultural climate of the city, and aims to meet the community's needs, developing projects that meet the council's strategic priorities.

Research, enquiry and investigation underpin the Biennial's creative activities. It commissions artists to work on its education projects who inspire learning, introduce new perspectives and alternative ideas, and encourage new ways of thinking. Its education programme addresses issues of sustainability in audience development, and maintains supportive relationships with existing audiences as well as developing new relationships. Promoting good practice, monitoring, evaluation and dissemination are integral elements of all activity planning.

Brighton Photo Biennial Education is supported by Brighton & Hove City Council and David Wilson Homes Ltd, Aim Higher, University of Brighton, University of Sussex, Creative Partnerships and Neighbourhood Renewal at Hastings Borough Council. The Biennial also fosters good working relationships with national bodies such as Engage, DfES, DCMS, Qualifications Curriculum Authority (QCA), Museums, Libraries & Archives Council (MLA), as well as its local education authorities.

BPB Education continues to develop new partnerships and devise new projects. The projects described here were planned during the eighteen months leading up to the current Biennial exhibition programme. While one is complete, the other three are ongoing at the time of publication and will extend the presence of the second Brighton Photo Biennial into 2007.

Hangleton School
Photography is Everywhere
Group composition

PHOTOGRAPHY IS EVERYWHERE

Throughout 2006 Brighton Photo Biennial, supported by Brighton & Hove City Council and David Wilson Homes, worked with University of Brighton School of Arts and Communication to devise a course for second-year photography and art students to learn the skills needed to deliver community arts projects in primary schools. This course, incorporated into the elective programme of the University of Brighton, ran for ten weeks in the Spring Term and fourteen students worked with Community Arts tutor, Annis Joslin.

The course was aimed at students interested in gaining an understanding of the issues involved in the field of community arts, and practical work experience. Over the ten weeks they were introduced to many aspects of working as an artist in an educational context, including teaching strategies, lesson planning and evaluation. The programme encouraged a multi-disciplinary approach that fused photographic processes with other art forms such as sound and painting. Students from arts disciplines such as fine art and performance, as well as photography, participated.

The project provided students with direct experience of working as an artist-in-residence in a primary school. They worked with teachers from five Hove primary schools to devise and deliver photography workshops to a class of pupils. The project enabled students, teachers and pupils to try things for the first time, take creative risks in a safe and supportive environment, and share the experience of learning together.

Pupils and teachers from one class from each of the following schools participated: Goldstone Primary School, Hangleton Junior School, Hillside Special School, Mile Oak Primary School and Peter Gladwin Primary School. They produced an impressive range of original photographic work that included giant collaged self-portraits, responses to listening to music, performance narratives and mixed media self-portraits.

A second course, informed by the evaluation of the first course and taught by Brighton-based photographer, Greg Daville, will enable a new group of up to twenty second-year art students to work in the five schools during Autumn Term. The school pupils will be able to consolidate and extend their photographic education through a visit to a Brighton Photo Biennial exhibition and further practical sessions.

The children's photographs are showing in a range of public places across Brighton and Hove during Brighton Photo Biennial period of 6–29 October 2006. One hundred posters are displayed inside Brighton & Hove buses. The culmination of phase one of the project is a final exhibition of the original work at the University of Brighton Gallery at Grand Parade from 10–18 November 2006.

Mile Oak School
Photography is Everywhere
Fantasy self-portrait; painted
cellophane overlay over photograph.

Peter Gladwin School
Photography is Everywhere
Photographic stories devised
and photographed by pupils

Hillside Special School
Photography is Everywhere
Photographs inspired by listening to music

Goldstone School
Photography is Everywhere
Group portrait, photo collage

148

SIGNS OF OUR TIMES

Greg Daville, a Brighton-based photographer worked alongside a class of GCSE Applied Arts students from Falmer High School in October 2005 to make new photographic and text-based work. The project took as a starting point the artist's own practice, an exhibition of pioneering photographs by Euan Duff and Peter Mitchell at the Gardner Arts Centre (*Archives From The New British Photography Of The 70s*), and material from the Mass Observation Archive, a collection founded in the 1930s to record the everyday lives of people in Britain, which is held at the University of Sussex.

The students visited the photographic exhibition and explored a range of the material at the archive that included personal diaries, photographs, reports and survey papers. Back at school, the students considered aspects of their own lives, and made observations about their immediate surroundings, and world events. They then used personal ephemera and digital photography to create their own work.

An important aim of this project was to raise the profile of career opportunities in the creative industries. Greg talked to the group about his own practice, and two Editorial Photography undergraduates from the University of Brighton showed the school students their own work, talked about student life, and worked alongside Greg as project assistants.

The students' photographs were exhibited in the foyer gallery at the Gardner Arts Centre, and their concertina notebooks, which revealed the thought processes behind the photographs, were displayed at the same time in cabinets at the University of Sussex Library. Following the exhibition, the students' work became part of the distinguished collection of the Mass Observation Archive.

Jahronimo [top]
Jayde
Signs of Our Times

150

LEARNING TO LOOK –
THE CREATIVE MEDICAL SCHOOL

During 2006 Brighton-based documentary photographer, Tom Wichelow, facilitated two eight-week courses that introduced first-year medical students to contemporary documentary photography. Together they explored similarities between the skills needed to practice medicine, especially diagnosis, and those needed to create photographs, grounded in the common territory of observation.

A series of artist-led practical and critical workshops introduced documentary photography and key issues relating to observation and perception. The students explored and reflected on the relationship between art and science, photography and medicine, through the analysis of and production of photographs. The project tested ideas and evaluated learning activities with the aim of developing a new model of practice that uses the principles of collaboration – sharing expertise, exchanging ideas and experience, engaging in dialogue – to inspire students' creativity, and to highlight the transferability of the skills used in scientific and artistic practice.

In 2003 Tom Wichelow was commissioned by Photoworks and the Brighton and Sussex Medical School to work with students to document the first year of the new medical school's activity. *Learning to Look* built on that project by enabling Tom to work again with undergraduate medical students. The new emphasis was on student learning, with a focus on monitoring, documentation, analysis and evaluation in order to investigate changes in students' attitudes, skills and expertise.

By the end of the course students had created a body of digital and black and white photography for exhibition, and a log book in which they recorded their reflections on the relationship between their photographic activities and their full time studies, and the impact this experience had on them as young doctors.

The project was supported by the Centre for Excellence in Teaching and Learning (CETL) in Creativity, a joint initiative of the Universities of Sussex and Brighton, and the Learn Higher CETL.

Student log book *Learning to Look*

Student work *Learning to Look*

152

THE ORE VALLEY REGENERATION PROJECT

Groups of pupils from Hillcrest Secondary School, Hastings, are working from May to December 2006 with Brighton-based photographer and curator Danny Wilson to produce a visual audit of Ore Valley housing estates that are undergoing regeneration. The students, who live on these estates, are using photography and text developed through site visits, interviews with residents and other activities to express the experience of living there.

The photographs and other work produced will make up an audit of current conditions that will inform the regeneration programme through exhibitions at community venues and by dissemination to the regeneration agencies as a digital archive of image and text.

By the end of the project students will have explored Farley Bank and Deepdene, and the Downs Farm and Broomgrove Estates, supported by Danny Wilson and school staff who have personal connections with these areas. At the end of the first phase of the project, July 2006, they had produced images that depict not only the physical environment, but also family life, friendship and the general concerns and activities of the young people living in the Ore Valley.

Hillcrest School is working with Creative Partnerships on a number of projects to enhance learning through creativity. The underlying educational aims of this photographic work are the development of creative expression in all media and a raised understanding of the designed physical environment and its effect on the community.

The project is a part of Hillcrest School's extended school programme that aims to link the school with local partners to create a learning community, and is supported by Neighbourhood Renewal at Hastings Borough Council.

Steven Manderfield
Kez Jordan
Ore Valley

ARTIST BIOGRAPHIES

Adel Abdessemed (b.1971 Constantine, Algeria) is an artist working with a variety of media, currently based in Paris. Between 1990-1994 he studied at the Fine Arts High School, Alger, followed by the Fine Arts National School, Lyon (1994-1998). Abdessemed works across video, animation, performance and sculptural installation. His practice can take on the grandiosity of the *memento mori*, as seen in his monumentally skeletal piece *Habibi* (2003), or the subtle rhythms of hybrid animated forms as in his video projection *God is Design* (2005), presented at Brighton Photo Biennial 2006. He participated in the 2001 P.S.1 International Studio Program in New York, where he also exhibited in *Uniforms: Order and Disorder* (2001). Solo exhibitions include FRAC Champagne Ardenne (2004). In 2006 Abdessemed was included in *Notre Histoire*, an exhibition of emerging French artists at the Palais de Tokyo in Paris.

Richard Avedon (b.1923, New York, d.2004, San Antonio, Texas) is one of the twentieth century's legendary photographers. At De Witt Clinton High School, he co-edited the school magazine with his classmate James Baldwin. He served in the US Merchant Marines where he photographed portraits for identification cards and passports. He returned to New York to study photography at the New School for Social Research with renowned art director Alexei Brodovitch. He then established himself as the leading fashion photographer for *Harper's Bazaar* and *Vogue*. All the while, he was creating portraits of artists, writers, actors, and intellectuals. In 1964, Avedon and Baldwin, by then a celebrated novelist, collaborated on the publication *Nothing Personal*. Together Baldwin's essay and Avedon's portraits reflect the culture of the Civil Rights Movement in the United States. Avedon was embraced by the art world for his portraiture, his work exhibited in museums throughout the world, including the Metropolitan Museum of Art in New York in 2002-2003 and the National Portrait Gallery in London in 1994-1995. He died in Texas while on assignment for The New Yorker magazine, where he was its first photographer.

Phyllis Baldino (b.1956, USA) is a New York based artist whose practice merges performance, video, sculpture and installation. Baldino received a BFA in Sculpture from Hartford Art School, West Hartford, Connecticut. Her work has been shown internationally and at the Museum of Modern Art, New York, the SoHo Guggenheim, Whitney Museum of American Art, Wexner Centre for the Arts, Contemporary Art Centre, Cincinnati, and in numerous national and international film and video festivals, including the Impakt Festival (2002, 2001, 1999), the New York Video Festival (2002), the Oberhausen Short Film Festival (2001), media city Seoul (2000), and the World Wide Video Festival (2000, 1998, 1996). In 2001 and 1996, she was a finalist for an international media/art award at the ZKM/ Sudwestrundfunk and International Video Arts Award in Baden-Baden.

David Claerbout (b.1969 Kortrijk, Belgium) attended the Nationaal Hoger Instituut voor Schone Kunsten, Antwerp between 1992-1995. Claerbout's work in video projection foregrounds the presence of time for the viewer, bringing together the qualities of moving and still images in an often disquieting analogue to the practices of photography and painting. A work such as *Vietnam 1967, near Duc Pho (reconstruction after Hiromishi Mine)* (2001) appears to be a projected still image but is, in fact, almost imperceptibly moving. Claerbout also produces still images and has used the internet (*Present*, 2000) as a means to explore the real and the virtual. He has shown internationally in public spaces and commercial galleries, most recently with solo exhibitions at the Van Abbemuseum, Eindhoven, Netherlands (2005) and at Dundee Contemporary Arts (2005). Claerbout's thirteen-hour film *White House* receives its UK premiere at Brighton Photo Biennial 2006. Claerbout is is currently based in Brussels and Berlin and is represented by Hauser & Wirth Zürich London; Johnen + Schöttle, Cologne; Yvon Lambert, Paris & New York and Micheline Szwacjer, Antwerp.

William Eggleston (b.1939, Memphis) is regarded as one of America's most significant living photographers. After a somewhat isolated early career, Eggleston's breakthrough came in the early 1970s when he began using the commercial dye-transfer process, giving his images a particular richness and saturation then unfamiliar to the museum world. His work using this technique was immediately championed by the Museum of Modern Art, New York, which gave him his first solo exhibition in 1976. Many exhibitions and photographic commissions followed, one of which was the 1984 project to photograph Elvis Presley's Graceland mansion. Eggleston has variously taught at Harvard, made a foray into video-making (the experimental documentary *Stranded in Canton*) and carried out commercial work for clients such as Coca Cola and Paramount Studios. He continues to show in major museum spaces, at festivals and with commercial galleries internationally.

Walker Evans (b.1903, St Louis, d.1975, New Haven) was an American photographer and writer credited with introducing clarity and precision into inter-war documentary photography. After a peripatetic education, he moved to New York to pursue a writing career but turned to photography in 1930. In 1933 he photographed conditions of poverty under the Cuban dictator Machado y Morales, setting a precedent for his pictures of hardship during the Depression in the American south, a project instigated by the Farm Security Administration. In 1935-36 he created a series of images of plantation houses in Mississippi and Louisiana, complemented by photographs of US Civil War monuments. In the late 1930s Evans famously used a hidden camera to photograph commuters on the New York subway. In 1938 the Museum of Modern Art staged a survey of Evans's tirelessly inventive first decade as a photographer, the museum's first exhibition dedicated to a single photographer. In the 1940s and 1950s he worked as photographer and picture editor for *Time* and *Fortune* magazines, and later taught at Yale. In 1973, still experimenting with new camera technology, he visited Sussex where he photographed Brighton landmarks with a candour typical of his long career.

Paul Fusco (b.1930, Leominster, Massachusetts) is a leading US reportage photographer. Fusco developed a keen interest in the medium as a teenager and in his early twenties served as a photographer during the Korean War. He then took a Bachelor of Fine Arts in Photojournalism at Ohio University, graduating in 1957. He moved to New York and worked at *Look* for which his reportage covered a range of social subjects, from miners in Kentucky to cultural experimentation in California. In 1968 he was aboard the funeral train of the assassinated Robert F. Kennedy, ostensibly to photograph celebrities, but instead he documented the emotional reactions of the crowds lining the railroad from New York to Washington DC. He joined Magnum Photos in 1974. His subjects since have ranged from the legacy of Chernobyl to the welfare system in New York. In 2004 Fusco created a series of photographs depicting the funerals of US military personnel killed in Iraq.

Alfredo Jaar (b.1956, Santiago, Chile) is an artist, architect and filmmaker based in New York. Jaar's projects, such as *The Rwanda Project* (1994-1998), use photography, text, lightbox, moving image and installation in various forms to challenge the mainstream media response to collective trauma. Jaar's major solo exhibitions include Macro, Museo Arte Contemporanea Roma; Museum of Fine Arts in Houston and MAMCO, Geneva. He has been included in various biennales, including Venice, São Paulo, Johannesburg, Sydney, Istanbul and Kwangju as well as Documenta in Kassel. In 1985 Jaar received a Guggenheim Fellowship and in 2000 was made a Mac Arthur Fellow. His new installation *The Sound of Silence* (2006) receives its UK premiere at Brighton Photo Biennial 2006.

Gabriel Kuri (b.1970, Mexico City) graduated in 1992 from the Escuela Nacional de Artes Plasticas at the University in Mexico City. Prior to this he spent several years in the workshop of artist Gabriel Orozco. Kuri completed his MA at Goldsmiths College in London in 1995. His work engages with memory and how we invest in objects. Kuri is interested in dialectics, working between material and semantics, object and image. Kuri's solo exhibitions include Galeria Kurimanzutto, Mexico City (2003); Galeria Franco Noero, Turin (2004) and MUHKA, Antwerp (2004). He was included in the 2003 Venice Bienniale and *State of Play*, Serpentine Gallery (2004). Kuri is currently based in Brussels and Mexico City.

Van Leo (b.Levon Alexander Boyadjian) was an Armenian-Egyptian studio photographer. His family fled as refugees from Armenia to Cairo when he was four. As a teenager, Van Leo developed a fascination for portraiture, glamour and the burgeoning Cairo film industry. He established himself as a professional B&W photographer during World War Two, when Cairo was awash with troops from across the British Empire, bringing a host of stars and entertainers to the city. Van Leo's makeshift studio saw the creation of thousands of images of movie stars, dancers, writers, generals and musicians. This was Cairo's flamboyant *belle époque*, during which Van Leo also created a vast number of self-portraits, using the studio to create staged tableaux of himself variously as prisoner, prince and – reflexively – as photographer. After the 1952 Egyptian Revolution, which ushered in a less glamorous era, he continued to work, reluctantly taking on colour portraiture in the 1970s. In 2000 Van Leo was awarded the Royal Netherlands Prince Claus Award, making him the first photographer ever to obtain the prize.

Glenn Ligon (b.1960, New York) is known for his resonant works in various media that explore issues surrounding race, sexuality, identity, representation and language. Ligon studied at the Rhode Island School of Design before receiving a BA from Wesleyan University in 1982. The recipient of numerous awards and fellowships, Ligon has exhibited internationally, and his work is included in the permanent collections of the Museum of Modern Art, New York, the San Francisco Museum of Modern Art, the Hirshhorn Museum in Washington, D.C., the Philadelphia Museum of Art, and the Walker Art Center in Minneapolis. Ligon is represented by Thomas Dane Gallery, London and Regen Projects, Los Angeles.

Steve McQueen (b.1969, London) works predominantly with film and video. Born in London, he studied at Chelsea School of Art and then at Goldsmiths College. He left Goldsmiths in 1993 and then studied briefly at the Tisch School in New York City. In 1996 he was awarded the first ICA Futures Award. In 1999 he received the Turner Prize following exhibitions at the Kunsthalle Zurich and the ICA in London. In 2002 McQueen was awarded an OBE and presented his acclaimed Artangel commission, *Western Deep/Carib's Leap*. McQueen lives and works in Amsterdam and London and is represented by Thomas Dane Gallery, London and Marian Goodman Gallery, New York & Paris.

Lee Miller (b.1907, Poughkeepsie, New York, d.1977, Chiddingly, Sussex) was a successful fashion model and fashion photographer in Paris during the 1920s. While in Paris, she also began her own photographic studio, becoming a major participant in the surrealist movement and also, in 1929, the muse of the artist Man Ray. With the outbreak of the Second World War, Miller ignored pleas that she return to the US and started a new career working freelance for Vogue. She documented the Blitz and was accredited to the US Army as a war correspondent, becoming an acclaimed combat photographer in Europe after the allied invasion. The estate of Lee Miller is represented by the Lee Miller Archives which is based in her old home Farley Farm House, East Sussex.

Richard Misrach (b.1949, Los Angeles) is a celebrated American landscape photographer. In the late 1960s he studied Psychology at the University of California, Berkeley, where he began photographing anti-war protests. His first book was *Telegraph 3 AM: The Street People of Telegraph Avenue, Berkeley*, published in 1974. The following year he began experimenting with nocturnal desert photography, which he followed with the monumental *Desert Cantos* series, in which he explored man's complex relation to the desert space. He is now credited with championing colour photography and large-scale printing during the 1970s, a time when such practices were rarely seen in the museum world. Among Mirsrach's many prestigious commissions, retrospectives and fellowships are a mid-career survey at the Houston Museum of Fine Arts in 1996, and the Kulturpreis for Lifetime Achievement in Photography, given by the German Society for Photography. His work is held in over fifty major collections. Misrach is currently based in California.

157

Henna Nadeem (b.1966, Leeds) graduated from the Royal College of Art in 1993. She has undertaken residencies at Camden Art Centre, London; University of Sunderland (commissioned by Autograph and the University of Sunderland) and at the London Print Studio. Her work has been included in various group exhibitions including *I want! I want!*, Northern Gallery for Contemporary Art, Sunderland and touring (2003-04), and *Landscape Trauma in the Age of Scopophilia*, Leeds Metropolitan University Gallery and The Gallery, London (2001/02). Solo projects include *trees water rocks*, Piccadilly Circus Underground Station, London (2004-05) and *Billy Bragg*, Billboard, Project Art Space, Dublin (2004). Nadeem had a solo exhibition at the Newlyn Art Gallery, Penzance (2005) and in 2006 was commissioned by Photoworks, Brighton for her series and book *A Picture Book of Britain*.

Mitra Tabrizian (b.1959, Tehran, Iran) studied photography at the Polytechnic of Central London (now University of Westminster). Her work has been concerned with a range of contemporary debates; from post-feminist and post-colonial theories to the effects of late capitalism in Great Britain, to the shifts and changes in post-Revolutionary Iran. She has published and exhibited widely and in major international museums and galleries. Her most recent book, *Beyond the Limits* is published by Steidl (2004). Her most recent film *The Predator* is funded by AHRB Innovation Awards (2004). The series *Correct Distance* (1986), on the *femme fatale* of Hollywood film noir, is published by Cornerhouse (1990). The artist lives and works in London.

Fiona Tan (b.1966, Pekan Baru, Indonesia) is an artist currently based in Amsterdam. As a child she emigrated with her family from Indonesia to Australia. She attended the Gerrit Rietveld Academie, Amsterdam, between 1988-1992, followed by the Rijksakademie van Beeldende Kunst, Amsterdam in 1996-1997. Tan's practice draws on the tensions between ethnography and personal travelogue. Often using or referring to photographic and filmic archive, Tan combines the two in expanded film and video installations. Her work often engages in ritual, as seen in the dual-screen video installation *Saint Sebastian* (2001). Tan was included in Documenta 11, Kassel; 49th Venice Biennale and the Berlin Biennale (2001) and was included in the 15th Biennale of Sydney (2006). Her recent solo exhibitions include Musee d'Art Contemporain, Montreal, Canada (2005) and *Countenance (and other works)*, Modern Art Oxford, Oxford, UK and Baltic Art Center, Visby, Sweden (2005); Landesgalerie, Linz, Austria; touring to Kunstmuseum, Bergen, Norway and Pori Art Museum, Finland (2006). Her film *Lapse of Memory* was commissioned for Brighton Photo Biennial 2006. Fiona Tan is represented by Frith Street Gallery, London.

Kara Walker (b.1969, Stockton, California) is a contemporary American artist who is best known for her exploration of race, gender, sexuality, and identity in her artworks. Walker's education includes an MFA at Rhode Island School of Design in Painting/Printmaking, and a BFA in Painting/Printmaking at Atlanta College of Art. Kara Walker's work has been exhibited at the Museum of Modern Art, New York, the San Francisco Museum of Modern Art, the Solomon R. Guggenheim Museum and the Whitney Museum of American Art. In 1997 she received a MacArthur Foundation award, and in 2002 she represented the US at the São Paulo Biennale in Brazil. Walker lives in New York and is on the faculty of the MFA program at Columbia University.

Andy Warhol (b.1928, Pittsburgh, d.1987, New York) studied in his native Pittsburgh and began his career as a fashion illustrator in New York. Warhol became a major proponent of Pop Art in the early 1960s and his images of movie stars, disasters, flowers, skulls, Maos, race riots and Americana became iconic images of the twentieth century. He also worked prolifically as a filmmaker, photographer, producer, publisher and diarist. The *Electric Chair* series of paintings was begun in late 1963, at the same time as his *Suicide*s series. The artist's 1971 reprise of *Electric Chairs*, seen at Brighton Photo Biennial 2006 in a series of screen-prints from the Tate collection, took place during the same year as his first Tate Gallery retrospective, in which Warhol's work was revealed to the British public in substantial form for the first time. Warhol survived a murder attempt in 1968 and died in 1987 from complications of routine gallbladder surgery.

Orson Welles (b.1915, Wisconsin, d.1985, Los Angeles) was a film, radio and theatre director, an actor, screenwriter, broadcaster and producer. A child prodigy, he excelled in many forms of entertainment. Welles's relationship with Shakespeare began in 1936 when the Federal Theater Projects assigned Welles to create a production of Macbeth. Moving the play from Scotland, Welles staged his Macbeth in Haiti, bringing a Voodoo context to the work. He gained national fame and notoriety for his 1938 broadcast of H.G. Wells's *The War of the Worlds*. Welles's directing was so convincing that US citizens famously took to the streets in panic. He is most noted for his 1941 film classic *Citizen Kane*, his first feature film directed at the age of 25. A structurally visionary film, *Kane* is regularly cited as one of the most influential movies in the history of cinema. Never far away from controversy, Welles's output after *Kane* was fraught with difficulty. Studio disputes often hampered his creative vision and he became as famous for his unfinished projects as for the ones he completed. The latter include the classic movies *The Magnificent Ambersons* (1942) and *Touch of Evil* (1958), in which he starred. His most widely known screen appearance is in Carol Reed's *The Third Man* (1949). He died at his home in Hollywood with various projects underway, including a movie of King Lear.

Picture Credits

Adel Abdessemed
© Adel Abdessemed
Courtesy the artist & Galerie Kamel
Mennour, Paris

Richard Avedon
Courtesy The Richard Avedon Foundation
© (1963) The Richard Avedon Foundation

Phyllis Baldino
Courtesy the artist

David Claerbout
Courtesy the artist and galleries Hauser
& Wirth Zürich & London; Johnen &
Schöttle, Cologne; Yvon Lambert, Paris &
New York; Micheline Szwacjer, Antwerp

William Eggleston
Courtesy Daniel Greenberg
and Susan Steinhauser

Walker Evans
p. 4, 31 & pp.121-5 © Walker Evans
Archive, The Metropolitan Museum of Art
p. 9 © National Gallery of Canada
p.85 Library of Congress, Prints &
Photographs Division, FSA/OWI
Collection, [LC-USF342-T01-008078-A]
p.87 & 89 © Walker Evans Archive,
The Metropolitan Museum of Art/
V&A Images

Paul Fusco
© Paul Fusco/Magnum Photos

Alfredo Jaar
Commissioned by Fotofest, Houston,
2006
Courtesy the artist

Gabriel Kuri
Courtesy the artist

Van Leo
Courtesy the Van Leo Collection, Rare
Books and Special Collections Library,
The American University in Cairo

Glenn Ligon
Courtesy the artist and Thomas Dane,
London

Steve McQueen
Courtesy the artist, Thomas Dane, London
and Marian Goodman Gallery, New York
& Paris

Lee Miller
© Lee Miller Archives, England 2006.
All rights reserved. www.leemiller.co.uk.

Feral Benga (leaning over body) in
Le Sang d'une Poete by Jean Cocteau.
Paris, 1930 (Photographer: Sacha Masour)
© The Artists Estate, courtesy of the
Lee Miller Archives, England

Richard Misrach
Courtesy Fraenkel Gallery, San Francisco
and Pace/MacGill Gallery, New York

Henna Nadeem
Courtesy the artist and Photoworks

Fiona Tan
© Fiona Tan
Courtesy the artist and Frith Street Gallery,
London

Mitra Trabizian
Courtesy the artist

Voodoo Macbeth
Archival photographs
Courtesy The Library of Congress,
Washington D.C.

Kara Walker
© Kara Walker
Image courtesy of Sikkema Jenkins & Co.,
New York

Andy Warhol
All pictures © Licensed by the
Andy Warhol Foundation for the Visual
Arts, Inc/ARS, New York and DACS
London 2006.

159

Acknowledgments

Brighton Photo Biennial gratefully acknowledges the support of the following individuals and organisations:

David Chandler, Rebecca Drew, Gordon MacDonald, Benedict Burbridge and staff at Photoworks;
Bruce Brown, Karen Norquay, Barry Barker, Colin Matthews, David Green, Mark Power, Chris Stewart and staff at the University of Brighton;
Catherine Moriarty and staff at the University of Brighton Design Archives;
Professor David Alan Mellor at the University of Sussex;
Jennie Thorne at In Retropect, Kemptown;
Carola del Mese and Jeff Bruce-Hey at Props Studios, Ditchling;
1 Stop Travel, Brighton;
University of Brighton Critical Fine Art Practice BA students;
Frank Gray at Screen Archive South East;
Tim Brown and Nicky Beaumont at Cinecity;
Janita Bagshawe, Helen Grundy, Mary Goody, Alexander Hawkey, Kevin Faithfull, Jody East, Martin Ellis and Andrew Barlow and staff at the Royal Pavilion, Libraries & Museums, Brighton & Hove City Council;
Matthew Miller, Liz Whitehead, and Danny Wilson at Fabrica;
Sue Webster, Claire Soper, Holly Steddon and Emily Coleman at the Gardner Arts Centre;
Colin McKenzie and Caroline Baron at Charleston;
Deborah Rawson, Simon Grennan and Monica Ross at Empowering the Artist (ETA) and Meta Space;
Alan Haydon, Emma Morris, David A Bailey, Celia Davies, and Helen Little at the De La Warr Pavilion;
The organisers of Brighton Photo Fringe and participating artists;
Felicity Harvest, Sally Abbott, Elizabeth Gilmore, Stephanie Fuller, Verity Slater and Jamie Wyld at Arts Council England, South East, and Helen Cadwallader and Mark Waugh at Arts Council England, National Office;
Paula Murray, Donna Close, Lucy Jefferies and Paul Hudson at Brighton & Hove City Council;

Jackie Lythell and Brighton & Hove Arts Commission; Jess Stockford and Michael Blake at A&B;
Hilary Lane at East Sussex County Council; Shaun Romain and Pam Jarvis at Sussex Arts Marketing;
Katherine Green and Richard Lonsdale at Red Leader Industries;
Dean Pavitt at Loup Design and Stuart Smith at SMITH;
Steve White and Lisa Creagh at Spectrum Photographic;
Nazira Miah at Burt, Brill & Cardens;
Roger Browning and Matt Virgo at Victor Boormans & Co;
Mandy Tyler and Claire Andrew;
Phillida Simpson at the Brighton Unitarian Church;
Gail Murray at the Brighton Dome;
Tessa Fitzjohn, Sarah Elderkin, Pauline Scott-Garrett, Alistair Upton;

The Daniel Greenberg and Susan Steinhauser Collection of Photographs, Lea Russo at Lea Russo and Associates Art Collection Management, Rose Shoshana at Rose Gallery;
Tse-Ling Uh and Bram Vandeveire at David Claerbout studio; Dimitri Riemis at Galerie Micheline Szwajcer;
Brigitte Lardinois, Emily Field and Sophie Wright at Magnum Photos, and staff at Hewlett Packard;
Norma Stevens, Jennifer Rizzuto Congregane and James Martin at The Richard Avedon Foundation, and Marguerite Lamkin Littman, the Estate of James Baldwin;
Myriam Misrach, Frank Goldman and Amy Eshoo at the Richard Misrach Studio;
Ann Thomas at National Gallery of Canada, Ottawa;
The Library of Congress, Washington D.C.;
Martin Barnes at Victoria & Albert Museum, Violet Hamilton and Polly Fleury at the Wilson Centre;
Jane Hamlyn and Charlotte Schepke at Frith Street Gallery;
Mark Wayman at ADI;
Soen Houw, Lesley Tan and Rubens and Niels Dijkstal Johan Leysen, Jaap van Hoewijk, Mufidah Kassalias, Stef Tijdink, Dirk Nijland, Jacques Ghijsels, Camilla Robinson, Tom d'Angremond, Hugo Dijkstal, Peter Delpeut and Soho Images;
Wendy Watriss at FotoFest, Houston;
Jeff Rosenheim at the Metropolitan Museum of Art, New York;

Julie Abdessemed; Kamel Mennour and Marie-Sophie Eiche at Galerie Kamel Mennour; Lamia Hosny Eid, Philip Croom and Amr Kamel at The American University in Cairo;
Anthony Penrose at the Lee Miller Archive;
BBC Television;
Erin O'Rourke at Sikkema Jenkins & Co, New York;
Ami Bouhassane, Simon Callow and Charlie Dark;
Gary Younge and Ana Ransom;
Jeff Wall and Runa Islam;
Alex Bradley at White Cube;

Adel Abdessemed, Alfredo Jaar, David Claerbout, Fiona Tan, Gabriel Kuri, Glenn Ligon, Henna Nadeem, Kara Walker, Mitra Tabrizian, Paul Fusco, Phyllis Baldino, Richard Misrach, Steve McQueen.

Nothing Personal c.1964 by James Baldwin was originally published by Athenum and Michael Joseph. Reprinted by arrangement with the James Baldwin Estate.
All rights reserved.

Brighton Photo Biennial Education:
The Biennial would like to thank consultants Penny Jones and Annis Joslin; artists Greg Daville, Tom Wichelow, Danny Wilson; Polly Gifford at the De La Warr Pavilion; Professor Helen Smith and staff at Brighton and Sussex Medical School; Pauline Ridley at The Centre of Excellence in Teaching and Learning in Creativity, University of Brighton; all University of Brighton students who have contributed to our work; and the following organisations, Aim Higher, Brighton & Hove City Council and David Wilson Homes Ltd, Creative Partnerships, CUPP at the University of Brighton, Neighbourhood Renewal at Hastings Borough Council.
The staff and pupils at: Goldstone Primary School, Hangleton Junior School, Hillside Special School, Mile Oak Primary School, Peter Gladwin Primary School, Falmer High School, Hillcrest Secondary School, Hastings.

160

779/BRI

Co-published by Photoworks and BPB on the occasion of the second Brighton Photo Biennial 6-29 October 2006

Photoworks
The Depot
100 North Road
Brighton BN1 1YE
T: +44 (0)1273 607500
F: +44 (0)1273 607555
E: info@photoworksuk.org
www.photoworksuk.org

Brighton Photo Biennial
University of Brighton
Grand Parade
Brighton BN2 0JY
T: +44 (0)1273 643052
E: mail@bpb.org.uk
www.bpb.org.uk

Edited by David Chandler,
John Gill and Gilane Tawadros
Editorial assistance: Ben Burbridge,
Stuart Croft and Rebecca Drew.
Designed by LOUP
Printed in Great Britain by
Dexter Graphics Ltd

British Library Cataloguing-in-
Publication Data. A catalogue
record for this book is available
from the British Library.

ISBN 1-903796-20-2

Photoworks is an independent arts
organisation that brings an international
perspective to promoting photography
in the South East of England.
Photoworks operates over four main
areas of activity: commissioning
new work, producing exhibitions,
publishing books and a twice-yearly
magazine, and developing the audience
for photography through education
and participation programmes.

Brighton Photo Biennial 2006 is
supported by Arts Council England
South East, the University of
Brighton, Brighton & Hove City
Council and Photoworks.

m0043695SA